In 1978, the LEGO Group launched a little yellow figurine into the world and never looked back. Over the course of forty years, the minifigure has exploded into a pop-culture phenomenon. Deceptively simple in design and yet endlessly adaptable, the LEGO® minifigure has proven to be a true work of art—a testament to the precision, creativity, and joy of the LEGO System. While it stands a mere four LEGO bricks tall, its reach is global.

This landmark volume explores the making of an icon and celebrates the colorful history, milestone moments, evolving design, and lasting impact of the one and only LEGO minifigure. With compelling interviews and essays, lush photography, and never-before-seen visuals from inside the LEGO archives and beyond, this book is an intimate look at the minifigure as a hero of play, a marvel of design, and the ultimate collectible.

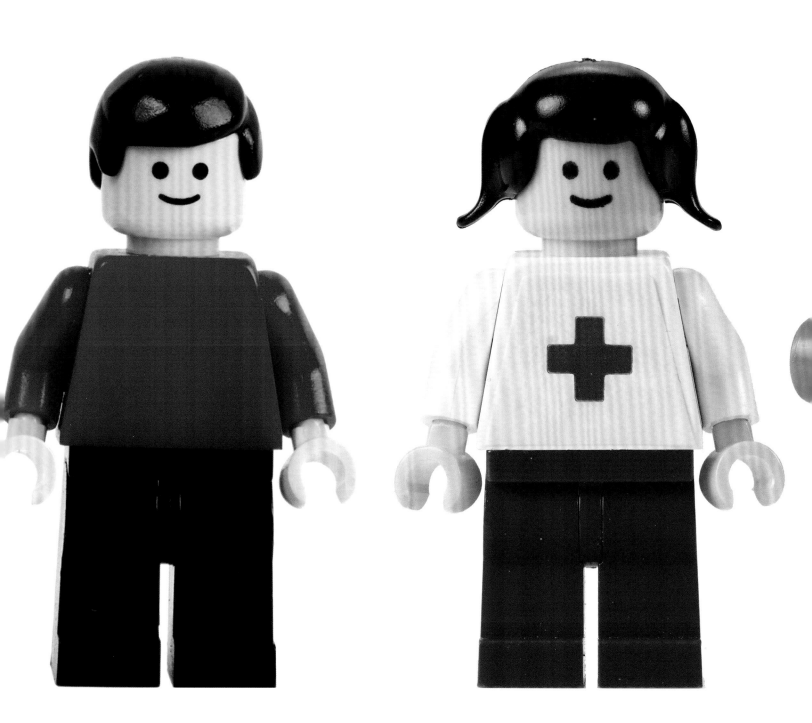

THE
ART
OF THE
MINIFIGURE

Brian Barrett

Foreword by
Matthew Ashton, Vice President of Design
Tara Wike, Senior Design Manager

CHRONICLE BOOKS

No part of this book may be reproduced in any form without written permission from the publisher.

Library of Congress Cataloging-in-Publication Data is available.

ISBN 9781452182261

Manufactured in China.

Design by Sara Schneider.

10 9 8 7 6 5 4 3 2 1

See the full range of LEGO® books and gift products at www.chroniclebooks.com.

Chronicle Books LLC
680 Second Street
San Francisco, California 94107
www.chroniclebooks.com

"LEGO® minifigures may be made for fun but there's a serious side to them as well. By offering an endless choice of role play possibilities, they're designed to let you play inventively, engage with different emotions, and tell your own stories."

—THE LEGO GROUP

CONTENTS

FOREWORD

8

INTRODUCTION

10

CHAPTER

1

BEFORE THE MINIFIGURE

12

CHAPTER

USE THE FORCE

72

CHAPTER

SERIES 1

90

CHAPTER

LIGHTS, CAMERA, EMMET

108

CHAPTER

8

WHAT COMES NEXT?

120

FINAL THOUGHTS

142

PHOTOGRAPHY CREDITS

144

ABOUT THE AUTHOR

144

FOREWORD

Ever since I first joined the LEGO Group in 2009, I have found myself at the heart of all things LEGO® minifigure. I had the great fortune of helping create the Collectible LEGO® Minifigure Series, the first product line to uniquely celebrate the minifigure itself. Our goal was to introduce iconic characters to spark creativity and inspire children of all ages to build and create freely. A mermaid might cue the creation of an underwater seascape, or a never-before-released caveman might spark the idea for a whole prehistoric world—all great reasons to dive back into the toy box and build something new! That goal remains, to me, the essence of the minifigure's purpose.

The joy of designing a LEGO minifigure comes from refining the character down to its purest essence, so its identity and personality instantly recognizable, while still respecting the classic color palette and clean design style of LEGO toys. Our graphic designers cleverly distill the essential details onto the limited canvas of the minifigure, adding subtle cues and fun details to inject personality into the characters. Our element designers expertly sculpt the minifigure's wigs and accessories to respect both the LEGO design style and the constraints of our precisely calibrated building system. All LEGO elements, including minifigure parts and accessories, are engineered to work together harmoniously. This symbiosis of engineering and aesthetics that we call the LEGO System in Play allows for limitless compelling LEGO creations, of which the minifigure is often the star!

We at the LEGO Group have come to embrace and celebrate the minifigure's power as a storytelling tool and brand icon. We've delighted in seeing it come to life in various forms and spread joy around the world, not only in our products, but also in books, films, rides, digital experiences, games, and more. And as the creators and caretakers of these beloved characters, we bear a great responsibility to make sure that, wherever they appear, they always live up to the LEGO brand values of fun, imagination, learning, caring, creativity, and quality.

We are so proud that the LEGO minifigure, with its simplistic form and quirky functionality, has persevered throughout the decades and continues to win hearts. (And I am personally very proud to have played a tiny part in helping spread that love!)

•

This book is a celebration of the LEGO minifigure and the art that it inspires. As you explore the pages, just imagine what worlds and stories these lovable characters might inspire in you!

TARA WIKE
Senior Design Manager, The LEGO Group

From a very early age, LEGO toys played a big part in my life. While I loved the creativity of building with the bricks, it was actually the cute, smiley little faces of the LEGO minifigure that drew me in, captured my heart, sparked my imagination, and gave me a reason to build!

While other toys at the time were created to realistically depict the characters they portrayed, or to play up the unrealistic proportions of popular muscle-bound heroes of the era, the LEGO minifigure did the exact opposite. Its design stripped away all those details and captured a character in its simplest form. I think the dinky scale, squat proportions, silly cylindrical head, trapezoidal torso, chunky little legs, and tiny, grabby claw hands all added up to something I found so endearing and charming.

The LEGO minifigure's blocky design matched perfectly with the aesthetic of the colorful brick-built world it inhabited, and it was so cleverly engineered to pose, walk, sit, and hold its accessories, you could simply snap and click the minifigure into place with whatever you built around it. This population of perfect plastic people opened up worlds of storytelling and inspired a generation of children to get creative, and to get building homes, vehicles, environments, and adventures for their little LEGO friends.

When I joined the LEGO Group in the early 2000s, I was disheartened to find that the company seemed to have lost sight of the power and appeal of its beloved icon. LEGO minifigures had become just accessories in the sets rather than the catalysts to adventure that they could be, and their styling had progressed from innocent and fun to aggressive and serious.

Over the years I worked with a team of minifigure champions to bring back some of the charm and positivity of the minifigure of the 1980s, and then take it to the next level by dialing up the personality, vibrancy, silliness, and fun. We refined our design style and introduced all kinds of new wigs and accessories to create a huge range of iconic, decodable characters with all kinds of play possibilities. This great variety of minifigures ignites a child's passions and inspires countless new stories and builds.

Through video games, publishing, TV shows, and ultimately the LEGO movies, we applied emotions and personality to these characters, allowing children to see minifigures in a new light and connect with them on a deeper level. These were no longer little bits of plastic just tossed into the LEGO tubs at home; they were characters that children believed in, fell in love with, and saw as their heroes and their inspiration to build new worlds.

●

I'm beyond proud of the thousands of LEGO minifigures that we have brought into the world, and I'm constantly amazed at the art and creativity that they inspire. This book showcases the incredible journey through space and time our beloved characters have been on, and all the costumes, professions, and personas they have tried along the way.

MATTHEW ASHTON
Vice President of Design, The LEGO Group

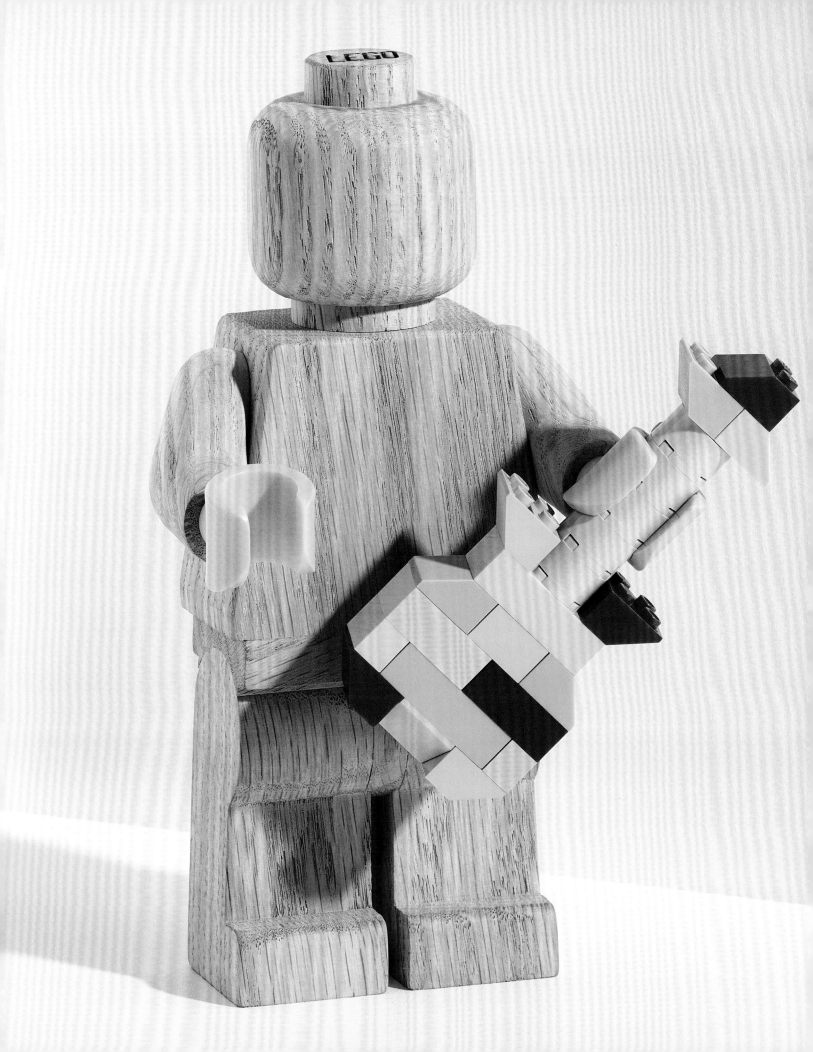

INTRODUCTION

The LEGO® minifigure. Today, it's a figure both instantly recognizable and infinitely adaptable. Minifigures adorn coffee mugs and pop art with equal aplomb. They star in movies and television shows. They've even been to outer space.

It wasn't always like this. In the beginning, the minifigures were almost an add-on when compared to the intricate brick creations they inhabited. For years they shared the same face, torso, hands, and legs. They were model citizens in the LEGO system, but never the star of the show.

So what happened? How did the minifigure evolve into the icon we know today? The answer doesn't fit together quite as neatly as a minifigure's components do. The ascent came in fits and starts. But the closer you look at the minifigure's evolution, the more compelling it becomes. LEGO® Pirates play a big part. LEGO® *Star Wars™* too. Look hard enough and you'll also find Voldemort, and ninja, and skeletons, and a big yellow book of closely guarded secrets. Oh, and Corn Cob Guy. Don't forget Corn Cob Guy.

Don't think of this book, then, as a taxonomy of minifigures. (For one thing, you'd need a lot more pages to fit them all in.) Think of it instead as an attempt to distill what makes the minifigure so durable, so ubiquitous, so essential. It's an exploration of those key moments in the minifigure's history that showed just how much more it had to offer, often told by the people who were there when it happened.

As far as journeys go, it doesn't want for variety. But through it all, the minifigure's lasting power hasn't been pop culture mimicry or multimedia adaptability. It's the ability to reflect the pure, undiluted joy of existing in a wholly constructed world back onto the person who made it. We love minifigures because we are minifigures. Or at least, because we can so clearly see ourselves in them.

CHAPTER 1

BEFORE THE MINIFIGURE

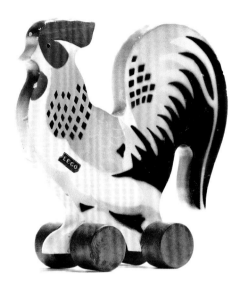

To fully grasp the minifigure's journey, you have to understand the ethos that has guided the LEGO Group at every level for the last nine decades. You have to understand the LEGO® System in Play.

The LEGO universe didn't always center on interlocking plastic bricks. The company's founder, Ole Kirk Kristiansen, got his start making wooden toys—along with more practical products like stepladders—in 1932. He bought an injection-molding machine in 1946 to add plastic to his repertoire. The first bricks came a few years later, in 1949. Those early versions were hollow underneath, meaning they fit together, but didn't click and stay together. But you could still stack them. And more importantly, beginning in 1955 you could mix and match all the pieces of every LEGO set. Different boxes and sets, all unified under the same system and scale.

"The LEGO System in Play means that all elements fit together, can be used in multiple ways, can be built together," said Ole's son, Godtfred Kirk Christiansen, who pioneered System in Play and would take over as the LEGO Group's managing director in 1957. "This means that bricks bought years ago will fit perfectly with bricks bought in the future." Even after the introduction of the stud-and-tube coupling system, which the company still uses today, that has continued to hold true. And with the stud-tube coupling system, bricks suddenly had the perfect clutch power; LEGO towers could be built taller and stronger without the risk of scattering elements around the room at the slightest bump.

What does this have to do with minifigures? It's a reasonable question. The obvious answer is that minifigures are constructed such that they can stand sturdy astride any brick. For all that's changed over the decades, System in Play persists. But the real reason to take a brisk stroll through early LEGO lore is because it so neatly explains the surprising prehistory of the minifigure. Because without System in Play, there would have been no building figure.

In 1962 a new innovation within the LEGO System drove the minifigure's story forward: The LEGO wheel was invented. For the first time

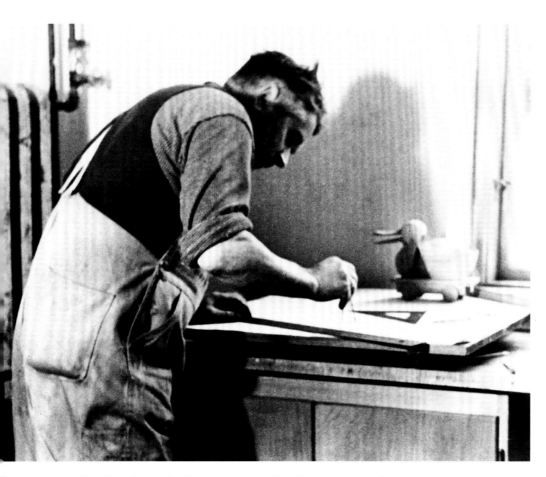

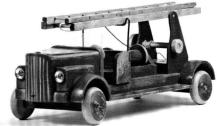

FIG. I.

FIG. 2.

FIG. 3.

FIG. 4.

FIG. 5.

FIG. 6.

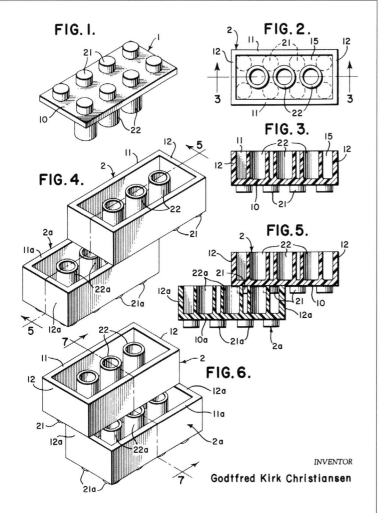

INVENTOR

Godtfred Kirk Christiansen

ABOVE: In 1932, spurred by a global economic crisis, Danish carpenters and joiners were encouraged to start making practical household items like stepladders and ironing boards, as well as wooden toys. Ole Kirk Kristiansen took up the challenge, crafting the now iconic LEGO duck, fire truck, and rooster—the foundation from which the modern minifigure would grow.

LEFT AND BELOW: Invented in 1958, the stud-and-tube coupling system lead to "clutch power"—that perfect balance where bricks hold together when built, but can still be easily pulled apart.

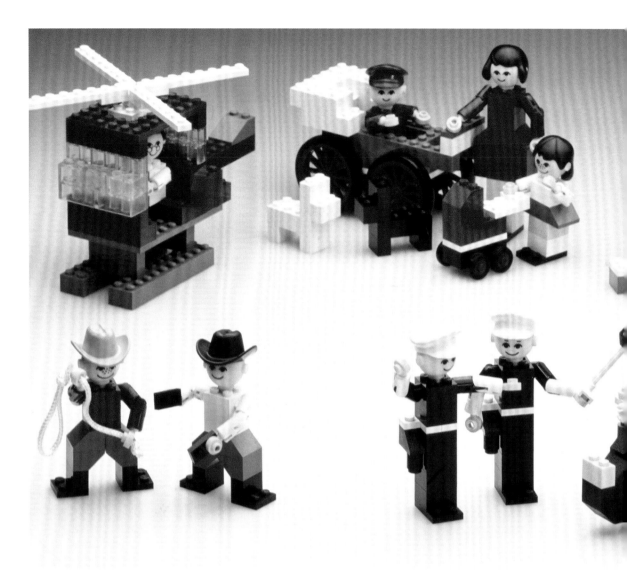

vehicles were being built completely from LEGO bricks. The next natural step was to create figures that could drive the cars, adding a new level to LEGO play.

The logic behind the building figure made sense at the time: Since everything in the LEGO universe comprises bricks, so should the people. This proved impractical, if only as a matter of scale. The building figures were giants with round heads and big ears, and because they were composed of stacked bricks, they stood or sat as built, more Pez dispenser than plaything.

Still, the building figures proved popular. Launching in 1974, one of the inaugural sets—

a grandmother, father, mother, and two children—won Toy of the Year from the UK's Toy Retailers Association. The LEGO Group would continue to produce them for several more years. But due to their size, creating worlds large enough for them to convincingly exist in bedeviled even the most ambitious aspiring LEGO architects.

"When we were supposed to make cars or vehicles, they were too big," says Jan Ryaa, a LEGO designer who has spent over four decades with the company. While the LEGO Group did launch a doll house–style set where the building figure actually fit inside, they did not fit the scale of most LEGO sets at the time.

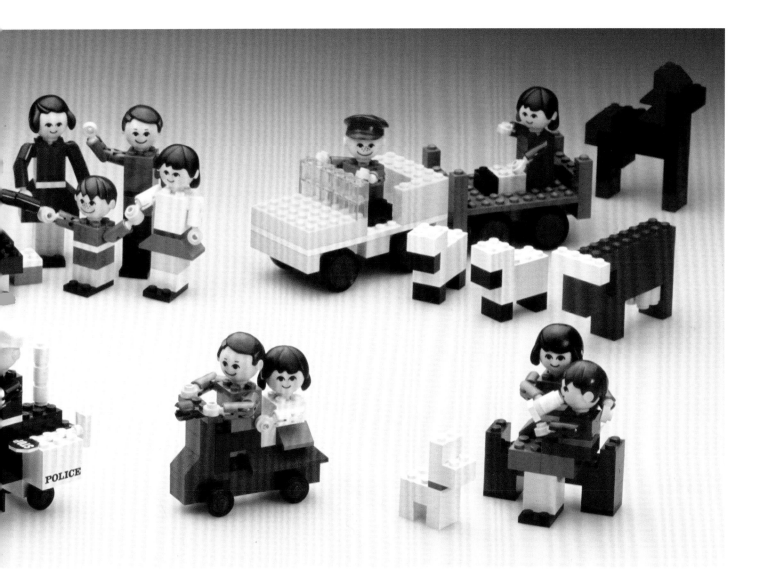

Nu kommer Lego-folket

Nu finns det små Lego-människor också. Som passar ihop med alla andra Lego-bitar. Dom kan sitta eller stå. Dom kan hålla i andra klossar eller hålla varandra i händerna. Dom kan bli tjocka eller smala. Stora eller små. Det är du själv som bestämmer hur dom ska bli.

Legofamiljen
Här är mormor, mamma, pappa och barna Lego. **14:—** Nyhet

Veteranflyg med pilot. **15:75** Nyhet

Väderkvarn, bil och två från Lego-folket. **20:50** Nyhet

Veteranlok med förare och en som åker med. **26:—** Nyhet

Alla priser cirkapriser inkl. moms.

Du bygger dom själv. Det är det som är roligt.

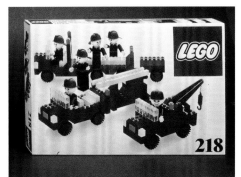

218

ABOVE: Building figures featured round heads with painted expressions, moveable arms, and bodies of stacked bricks.

LEFT: Grandma poses with a double-decker bus. To make vehicles proportional to the building figure took an ungainly—and impractical— amount of bricks. The building figure either towered over LEGO sets, or require huge builds to maintain scale.

As was so often the case in those years, Godtfred Kirk Christiansen had the answer. Rather than making the cars and buildings bigger, LEGO designers would offer a smaller character to inhabit them. Designer Jens Nygaard Knudsen spearheaded the effort to shrink things down to size. The result, after a little trial and error: an armless, faceless, blobish figure, precisely four bricks tall, known internally as the Stage Extra.

You can see hints of the full-fledged minifigure in the Extra, in the same way a half-finished sculpture presages the finished work. Still, the differences are striking.

The Extra came out in 1975 and sold concurrently with the building figure for the next few years. But even then, it was just a stopgap. Jens Nygaard Knudsen was already hard at work at something better.

One debt the minifigure owes the building figure and the Extra? Its iconic yellow head. At the time, the LEGO palette consisted primarily of just a few colors: red, yellow, white, blue, black, and occasionally green and gray. Given those constraints, it was decided to use yellow for the new figures.

MEET THE EXTRA:
NO FACE, EYES, OR SMILE.
MOLDED PENGUIN FLIPPERS.
MONOLITHIC FEET AND
RHOMBUS LEGS.

RIGHT: While a bit plain when compared to the minfigure we know today, the Extras were undeniably better attuned to the LEGO System in Play than the building figures that came before them. The two styles of figures were sold simultaneously for many years.

BELOW: Space exploration was serious business for the building figure in the 1970s. They made their interstellar voyages with helmets and clear visors, but no smiles.

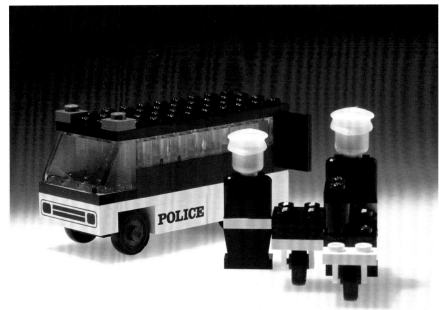

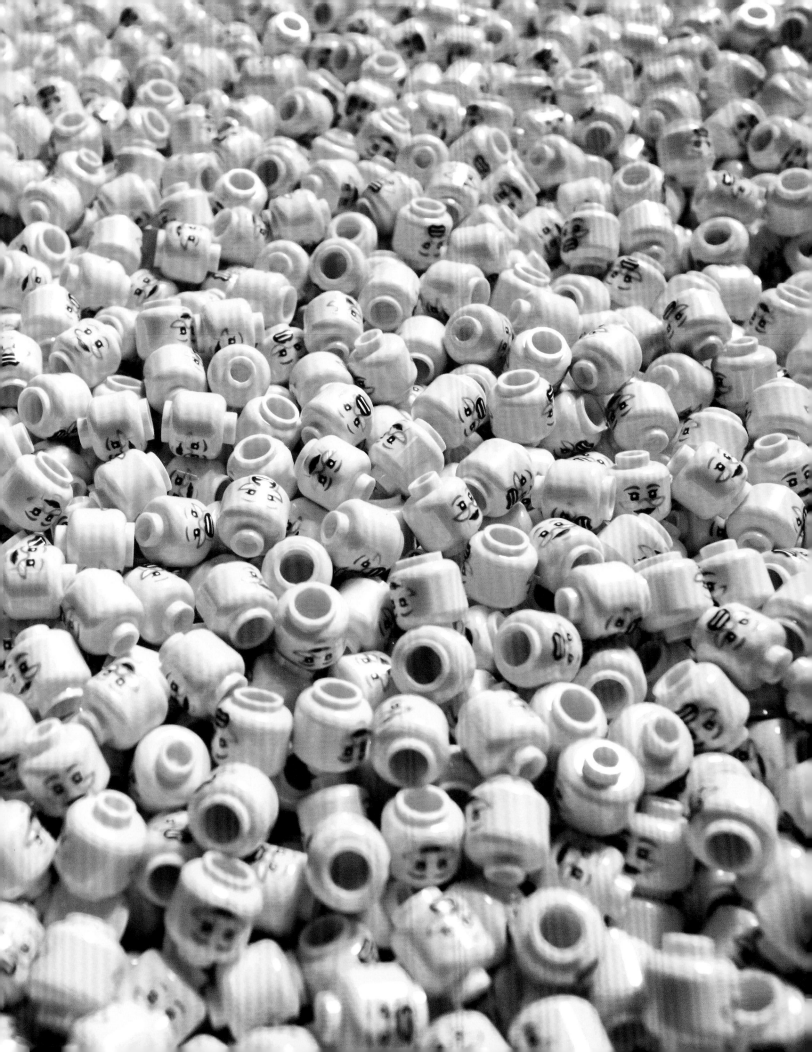

CHAPTER 2

MAKING A MINIFIGURE

It's not that LEGO® designers thought the Extra didn't need luxuries like a face or articulated limbs. The technology just hadn't caught up. "We were not yet capable of making facial expressions on heads that small in a satisfactory quality," says LEGO corporate historian Kristian Reimer Hauge. "We needed to figure out how to do that in a quality we were happy with."

As early as 1976, LEGO designer Jens Nygaard Knudsen would tinker away in his kitchen at night on minifigure prototypes made out of tin, bringing them into the office during the week. Godtfred Kirk Christiansen would come in over the weekend to see what sort of progress had been made and then suggest subtle changes.

The process continued for months, a continuous cycle of refinement. Every element received intense scrutiny. "Are the arms going to be straight down? Are the hands going to be twistable?" recalls former LEGO design master Jan Ryaa. "The hand is very complicated, because there is a knob function on top of the hand and a grip function inside the hand."

By 1978, they were satisfied. The minifigure as we know it today was born.

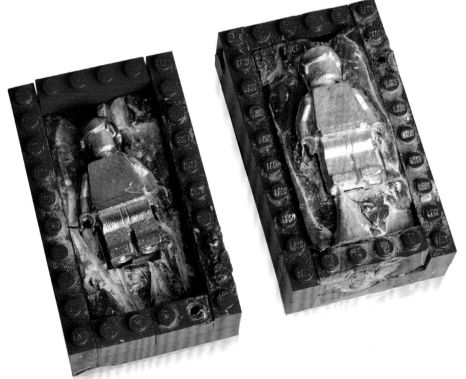

ABOVE: Experimentation yielded a wide range of minifigure prototypes, from boxy-headed cops to astronauts with barely any heads at all.

LEFT: Early tin minifigure prototypes bear more than a passing resemblance to Han Solo entrapped in carbonite.

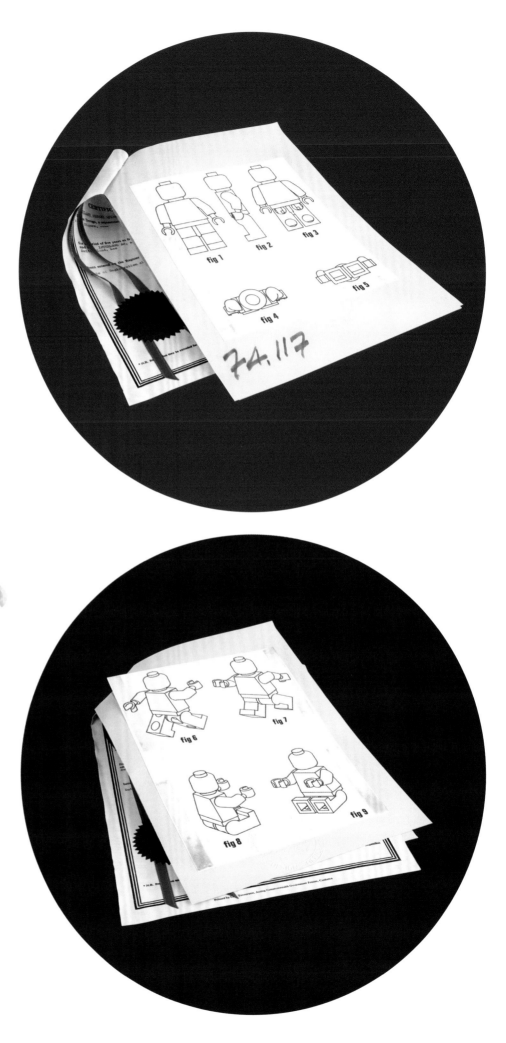

ABOVE: The first short-haired hairpiece was introduced in 1979 and has been an iconic LEGO look ever since. It's been used in more than 130 sets, and never once needed a trim.

RIGHT: While the minifigure has evolved in countless ways since 1978, its literal dimensions have rarely strayed from those outlined in the original patent.

MANUFACTURING

For all that minifigures have evolved over the last four decades, the process of manufacturing them has remained, comfortingly, the same. And much of it still happens in Billund, Denmark—where Ole Kirk Kristiansen founded the LEGO Group in 1932 and where the company's international headquarters remain.

The process starts with tiny, opaque granules of acrylonitrile butadiene styrene—ABS plastic to its friends—that sit in giant metal silos at the LEGO factory, like stockpiles of grains of sand. The colors for most elements are mixed on-site; designers currently have fifty-five unique shades to choose from. Once dowsed with the proper shade, the tiny plastic pieces are heated, first at 175 degrees Fahrenheit to make sure there's no water lurking, then at around 350 degrees Fahrenheit to melt the granules down before they're pressure-fed into a molding machine. Once the mold has shaped the plastic goo, cold water jets in to cool and harden the ABS. The mold then opens, and out drops a mass of LEGO elements.

The scale at which this happens is almost unfathomable, but some numbers might help you fathom it. The Billund factory alone houses 800 machines that can each accommodate 3 molds, so about 2,400 molds total. They operate 24 hours a day, 7 days a week, with a staff of 700 workers splitting up the shifts. A single LEGO minifigure head mold produces 36 heads in a single shot; a mold will generally hold out for 5 million shots before it requires maintenance or repair.

ABS isn't the only material the LEGO Group uses, it's just the most common. Transparent elements use a polycarbonate polymer; for tires and elastics, it's styrene butadiene styrene.

Minimizing waste is a powerful part of the LEGO ethos, and the factory is no exception. After each shot, the mold dispels materials that didn't go into the element itself. That excess goes straight into a

grinder, where it gets broken down into small pieces that can be heated again and pressed into the mold.

Getting the ABS through the mold isn't quite the finish line though. If it were, minifigures would have no faces. Or bodies. Or boxes to travel to you in. Fortunately, the rest of the process is every bit as efficient as you would expect from the company behind the interlocking LEGO brick.

Once a mold has pumped out enough pieces—each is programmed to keep track of the exact number—an automatic guided vehicle transports the brimming bin to a conveyer belt. The container gets a shake to make sure the pieces inside are level, and passes through a metal detector in case something snuck in that shouldn't have, like a stray spring. If a bin sets off an alert, it gets shuffled off on another route for human inspection. Similarly, each box gets weighed before it heads for storage; if it's more than a gram or two off, it's not allowed to pass.

The elements that sail through head to a warehouse that can fit 284,000 boxes, stacked high into the sky. There they sit, awaiting transit to a separate facility that handles design, assembly, and packaging. That's where the printed parts—the smirks, the shirts, the eye patches—are applied, right before the compiled sets hit the shelves.

The details have changed over the years, like the number of available colors and ratio of materials in play. Some innovations, like two-component molds that can create multi-colored elements, have pushed LEGO manufacturing forward. But the core of the process remains virtually unchanged—not unlike the minifigure itself.

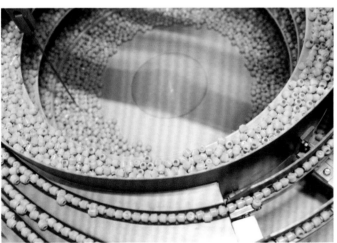

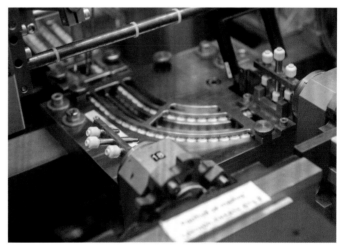

ABOVE: LEGO bricks and minifigures are manufactured in Billund, Denmark, near the company's international headqurters, as well as in Hungary, the Czech Republic, China, and Mexico.

LEFT AND FOLLOWING SPREAD: New minifigures receive a joyful expression before linking up with their torso, arms, hands, and legs. The molds used to produce minifigures effectively haven't changed in forty years, other than a boost in capacity.

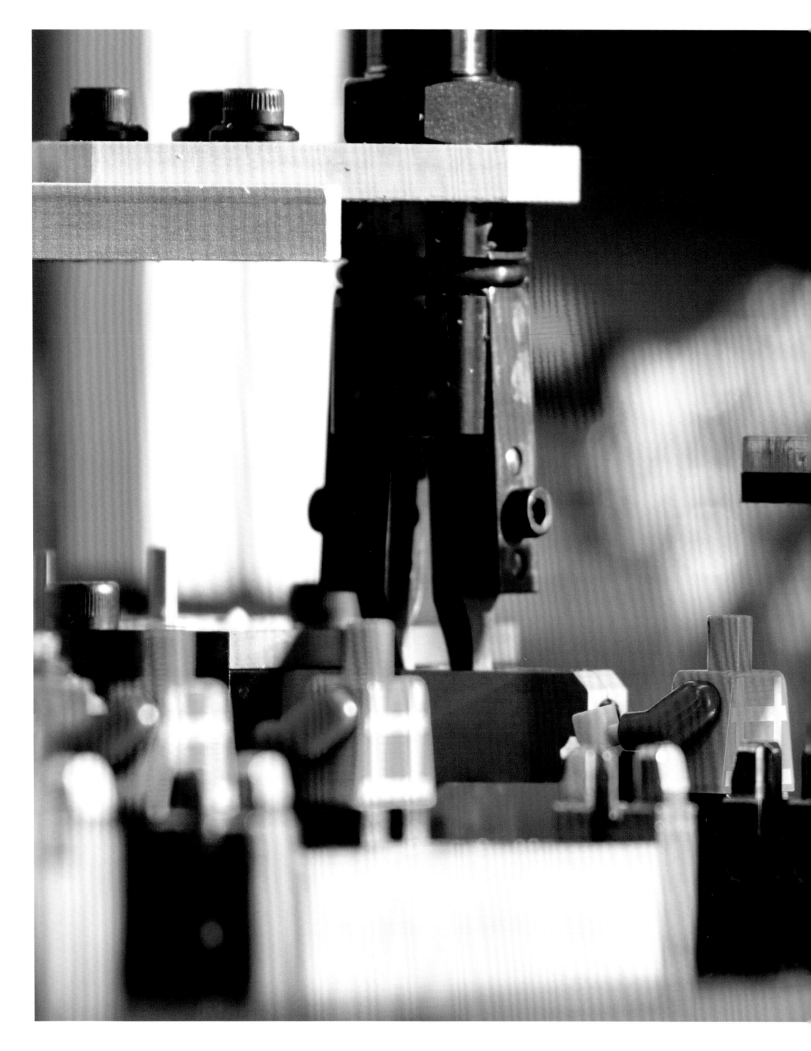

THE LEGO GROUP HAS PRINTED OVER 650 UNIQUE MINIFIGURE FACES, BUT THEY'RE ALL THE SAME UNDERNEATH THE INKS.

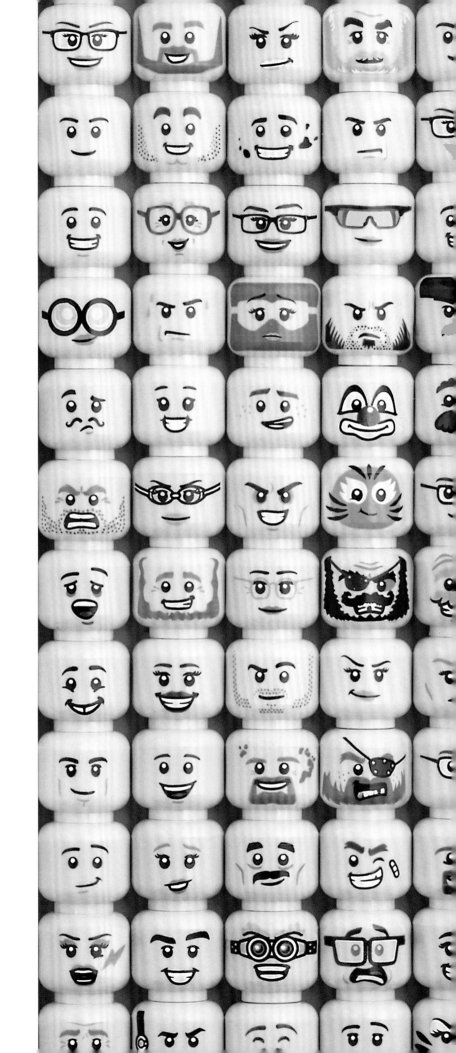

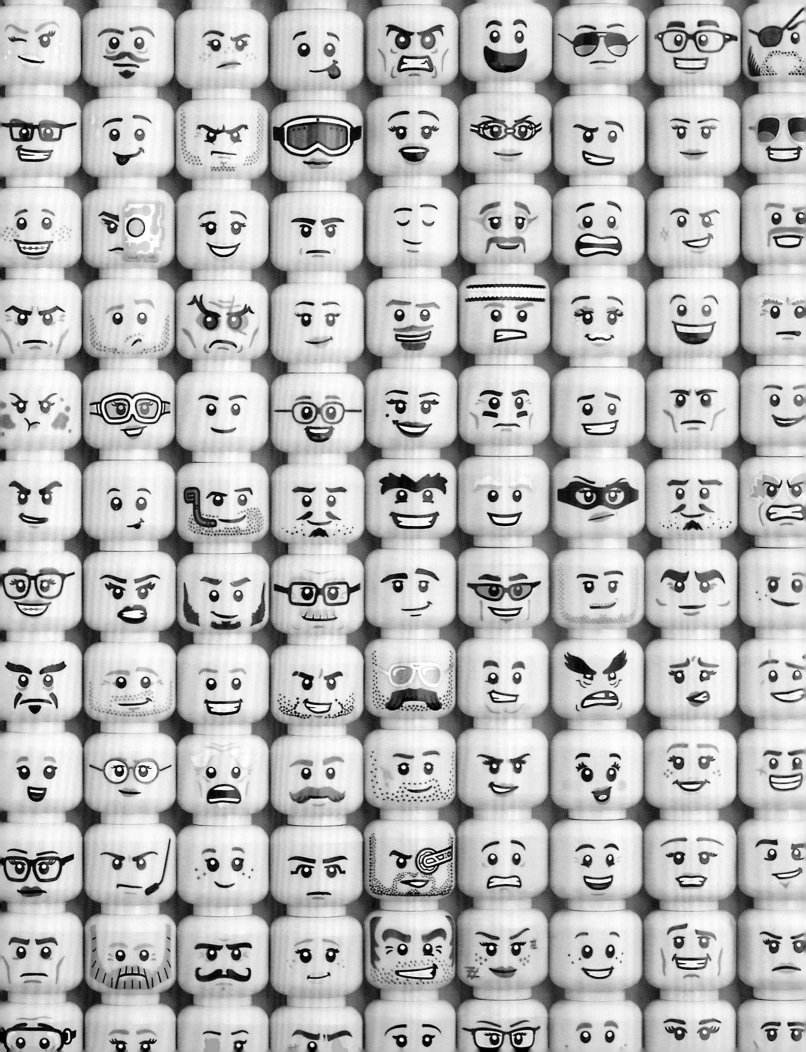

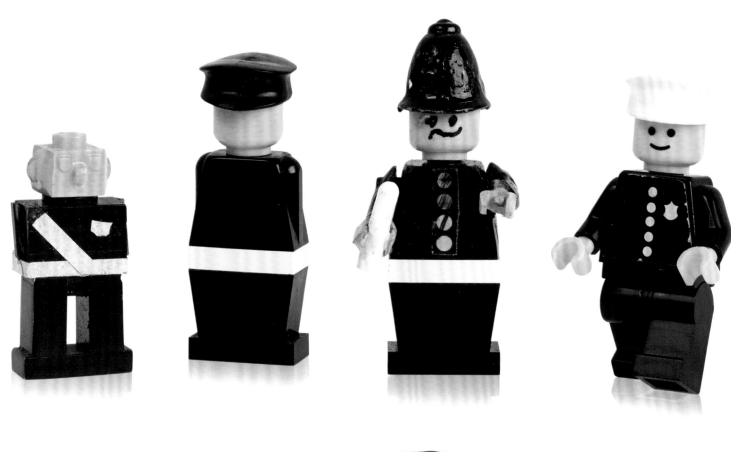

ABOVE: Prototypes of early police officers. Designed to reflect the community's everyday heroes, early LEGOLAND Town sets were populated by police officers, firefighters, doctors, and nurses—characters with recognizable professions were chosen to help children activate their imaginations through role play.

FACE:
TWO DOTS
AND A LINE

TORSO
DESIGN:
STICKER

Policeman
Released 1978

HEIGHT: FOUR BRICKS

ELBOW
BEND:
SLIGHT

LEG
ROTATION:
90 DEGREES
FORWARD,
45 DEGREES
BACK

WEIGHT: 3 GRAMS
WALL THICKNESS: 1.48 MM

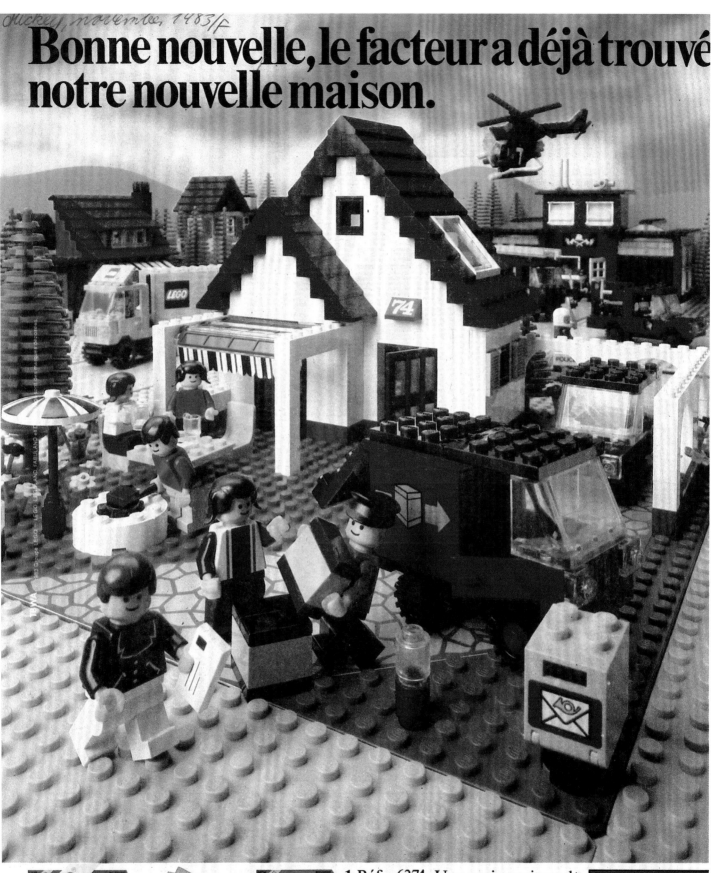

Mickey, novembre 1483/F

Bonne nouvelle, le facteur a déjà trouvé notre nouvelle maison.

1 Réf. : 6374. Une vraie maison de campagne avec cuisinière, salon, chambre à l'étage et barbecue dans le jardin. **2** Réf. : 6304. 2 croisements. **3** Réf. : 6624. Le camion livraison. La porte arrière peut s'ouvrir pour charger les colis.

Legoland ville : jouez dans votre propre ville.

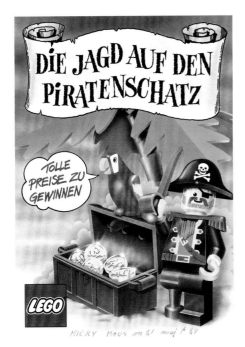

DIE JAGD AUF DEN PIRATENSCHATZ

TOLLE PREISE ZU GEWINNEN

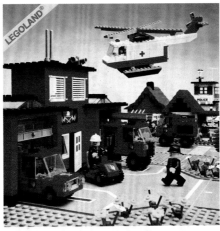

Da sitzt jeder Handgriff. Die Männer von der neuen LEGOLAND® Feuerwehr packen zu.

*NEU!

LEGO- jeden Tag ein neues Spielzeug

LEGO LEGO レッツGOレゴ!! LEGO LEGO

南海の勇者 バトル・クイズ

Ohne unseren neuen Raum-Roboter wären wir verloren.

Jetzt gibt es viele neue und spannende Modelle für Deine Abenteuer im Weltraum. Hol sie Dir und starte zum Entdeckungsflug in neue Welten.

LEGO 1980

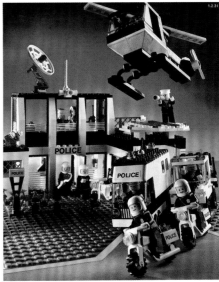

Urgent call for Special Task Force!
For all LEGOLAND® Town fans: the new super police station and 13 other breathtaking new ideas.

LEGOLAND Town

920379

PAZZI MATTONCINI
IN DIRETTA DALLA LEGO®

I TRENI LEGO SONO SEMPRE IN ORARIO!

Per Legoland si parte!

Officially a part of the LEGO System from birth and embraced by LEGO fans and builders around the world, minifgures were here to stay. A new chapter of the LEGO story had begun.

CHAPTER 3

CASTLE, TOWN, AND SPACE, OH MY!

By 1978, the LEGO® minifigure was ready for its close-up. It took its place across three LEGO play themes: LEGOLAND Castle, LEGOLAND Town, and LEGOLAND Space, meant to represent the past, present, and future.

It's important to remember that the minifigure was meant to bring role play to the LEGO System, an addition to the impressive brick sets that surrounded them. They all shared identical facial features. In that first year, stickers provided detail for the torso and elements like shields—although designers quickly thought better of it.

"We did make a printing setup for minifigures rather quickly after the LEGOLAND Castle set launched, because we thought that those stickers, when they've been sitting on a minifigure and children have been playing around with it, it looks horrible," says design master Jan Ryaa. "So we needed to find a way to decorate it."

The introduction of the minifigure was notable also for what it lacked: conflict. Godtfred Kirk Christiansen wanted none of it, to the point that designers were discouraged from using gray, green, or brown bricks out of concern that children could use them to build tanks or other instruments of battle. That's why the first LEGO castle is an unorthodox yellow.

That ethos extended to the early elements, the tools that accompanied the minifigures. Swords couldn't be too sharp or point directly at another minifigure. This neutrality made the early minifigures a perfect blank slate for imaginative play. "When you are making cars, very often you play by racing against each other, or seeing how far you can go," says Jan Ryaa. "But the minifigure in the castle actually was the actor; [they] could jump on the horses, or have a tournament." And so much more.

RIGHT: The Blue Knight first appeared in set #375 in 1978 with stickers deocrating his tabbard and shield. One of the first minifigures cared for hosptial patients in the LEGOLAND Town play theme.

BELOW: Not only did all of the early minifigures have identical bodies and faces, but accompanying elements like hats, hairpieces, and helmets also had to carry over across the three play themes.

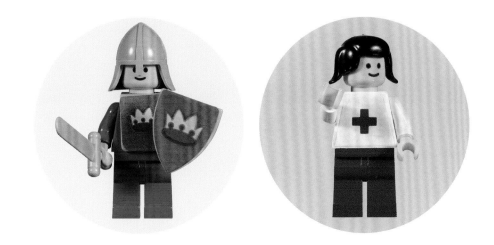

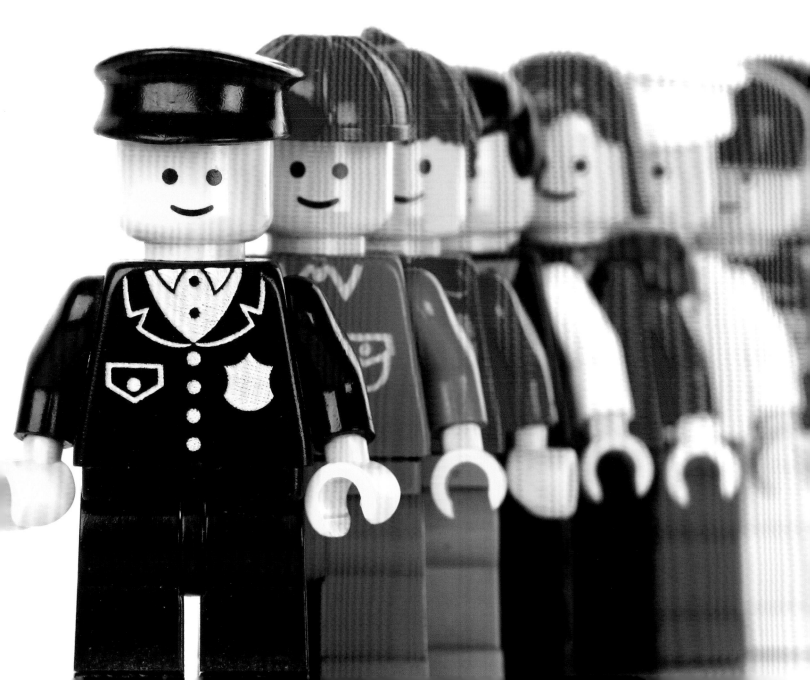

CASTLE

The first LEGO Castle was set #375, built in a surprising hue that would forever cement its place in history as "The Yellow Castle." An immediate bestseller, the set was home to fourteen minifigures and four brick-built horses.

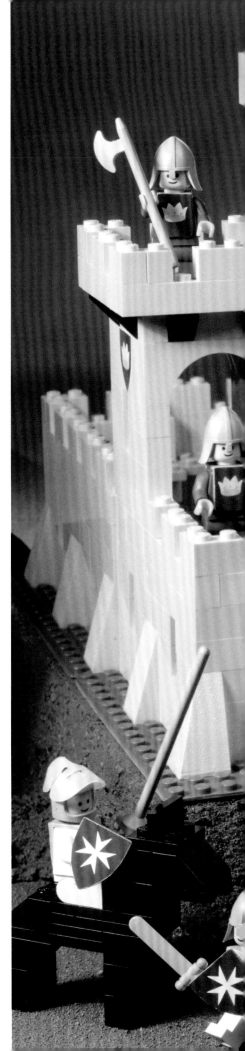

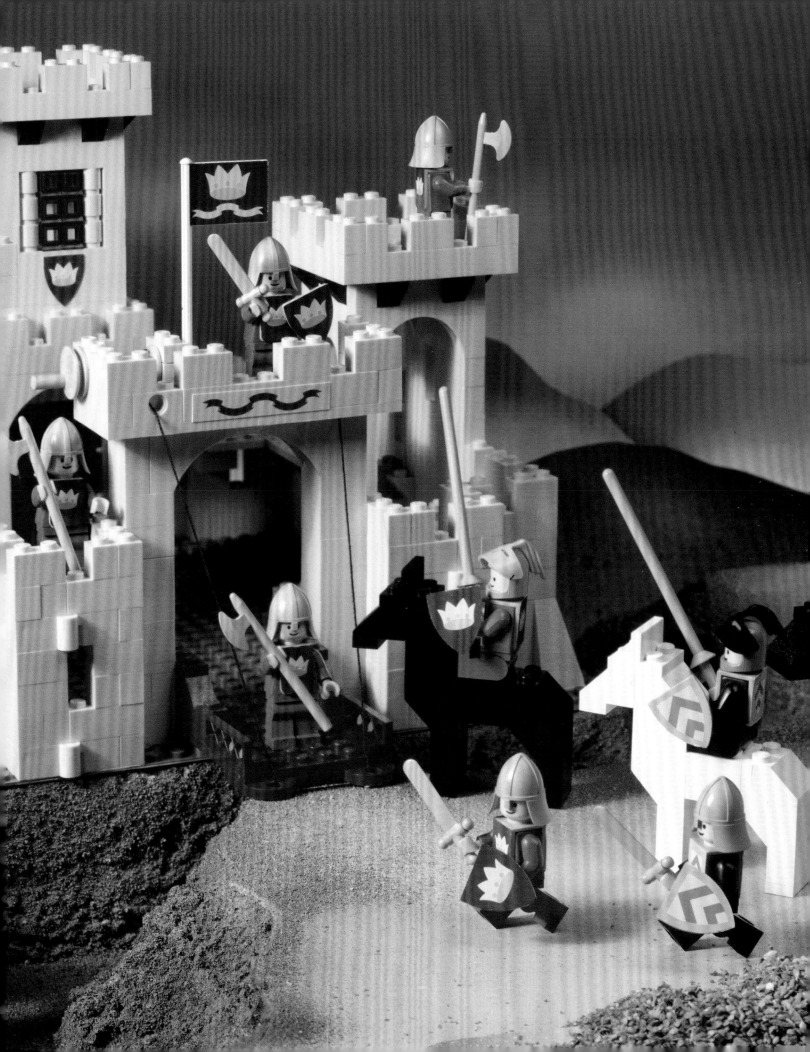

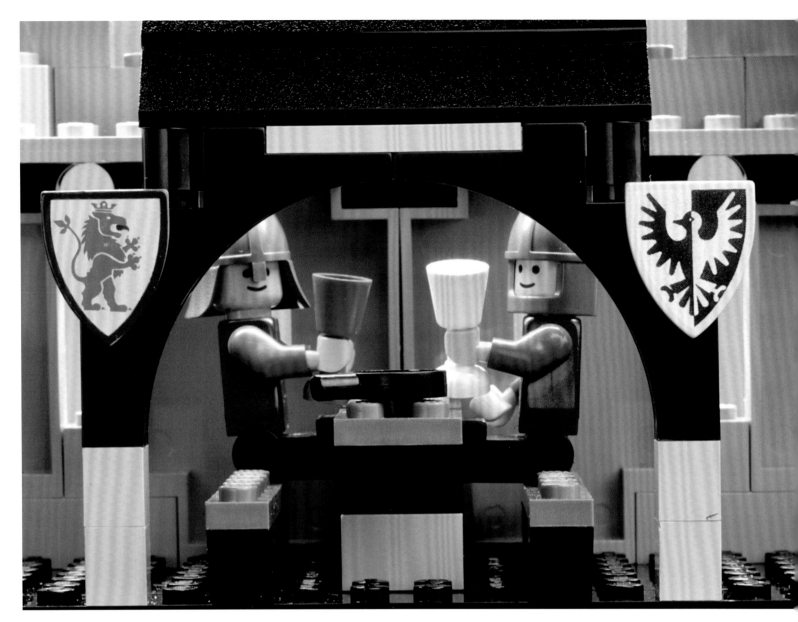

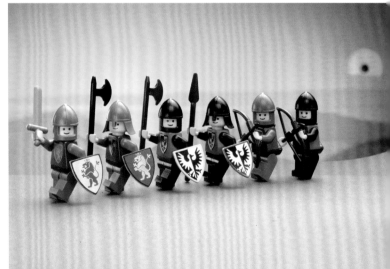

THE ART OF THE MINIFIGURE

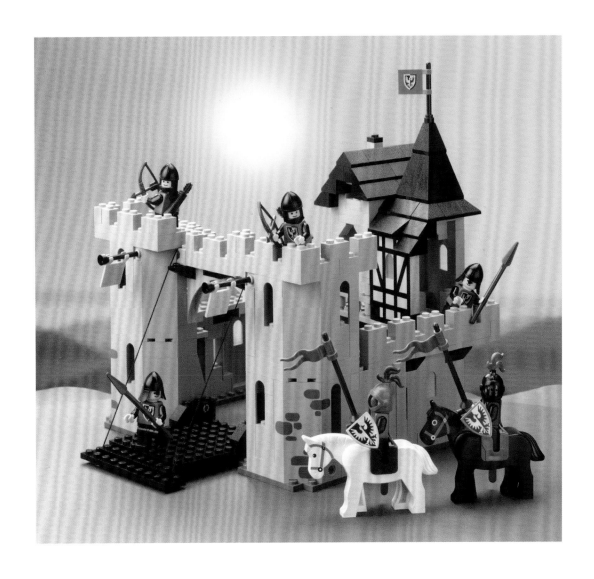

**EARLY LEGO KNIGHTS LIVED THE GOOD
LIFE. BUT BY THE MID-1980s THE SUN ROSE
ON A NEW ERA. SETS INTRODUCED THE
OPPOSING FORCES OF THE CRUSADERS
AND THE BLACK FALCONS, MORE REALISTIC
GRAY CASTLE SETS, ONE-PIECE HORSES,
AND MORE COMPLEX WEAPONRY.**

THE FORESTMEN: A NEW FOE IN A FEATHERED CAP. IT TURNS OUT YOU CAN HAVE NICE BAD GUYS.

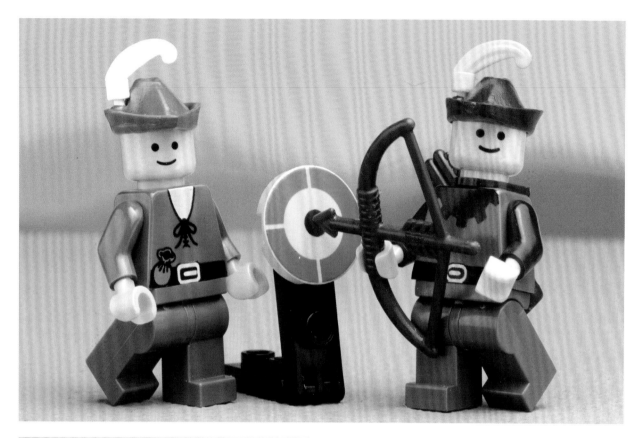

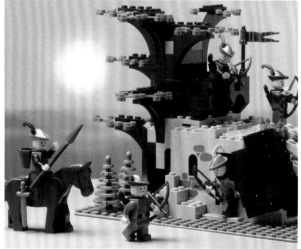

While the early LEGO sets left conflict out of the storyline, designers still found ways to create a little friendly friction. Nowhere is that more evident than the introduction of the Forestmen in 1987. "Jens Nygaard Knudsen and I, we grew up with Robin Hood," says designer Niels Milan Pedersen. "They're robbers, but they're nice robbers. So you can have nice bad guys."

THE NON-MINIFIGURE FIGURE

Other examples include:

LEGO Friends Mini dolls

LEGO Fabuland Figures

LEGO Microfigures

LEGO Nanofigures

and more . . .

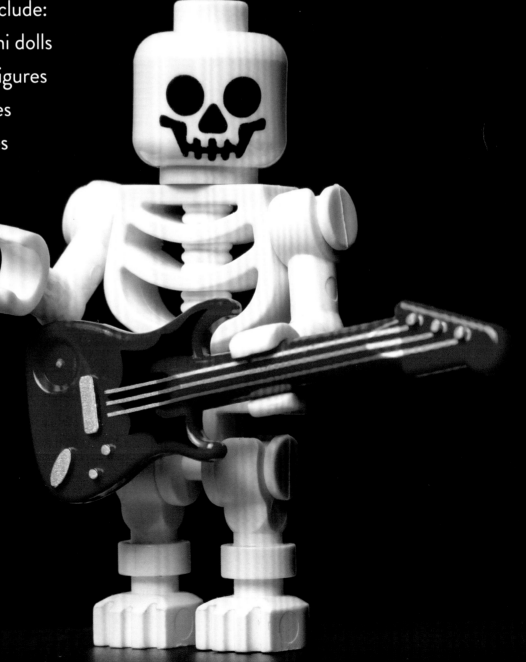

Eventually, the LEGO Group would take more risks with the minifigure, like the "non-minifigure figure" skeleton that came out in 1995. (While not a true minifigure from a technical standpoint because it doesn't have enough standard parts, the skeleton is considered a close cousin to its yellow brethren.)

Just a decade earlier, designer Niels Milan Pedersen hit a brick wall when pitching such an out-of-bounds concept. "[They] didn't want us to change the minifigure . . . It should always be smiling," Pedersen says. "I built a castle with a dungeon in it. And what do you put in the dungeon? I made a little LEGO skeleton and put it there. That was just for fun."

"You could always see in the morning that Godtfred Kirk Christiansen had been there. He was so interested in what we had made, so he came more than once a week, often several days a week. He had seen that skeleton in that castle. The next day I was called into his office, and he was looking at me. . . ." Let's just say Pedersen's boney friend was not well-received. Minifigures were not supposed to be deceased.

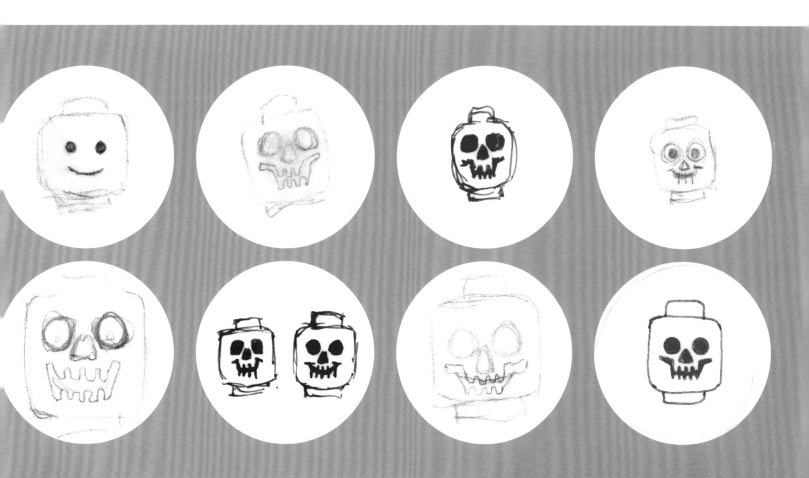

ABOVE: These bare-bones sketches of the original skeleton figure show just how much consideration goes into the tiniest facial detail. While not technically a minifigure, the result was an iconic addition to the LEGO stable.

TOWN

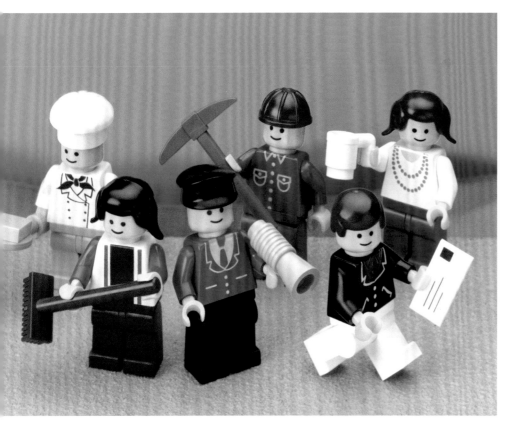

The LEGOLAND Town play theme exploded in the 1980s and '90s to include hundreds of minifigure professions and personalities. Classic LEGO sets from the '70s—anything with houses, cars, trains—were re-scaled and reimagined to match the new minifigure proportions. LEGOLAND Town would eventually blossom into LEGO City, with good citizens stepping into every imaginable role along the way.

HELP WANTED: DOCTORS, MAIL CARRIERS, CHEFS, POLICE OFFICERS, FIREFIGHTERS, CONSTRUCTION WORKERS. NO EXPERIENCE NECESSARY. (HATS REQUIRED.)

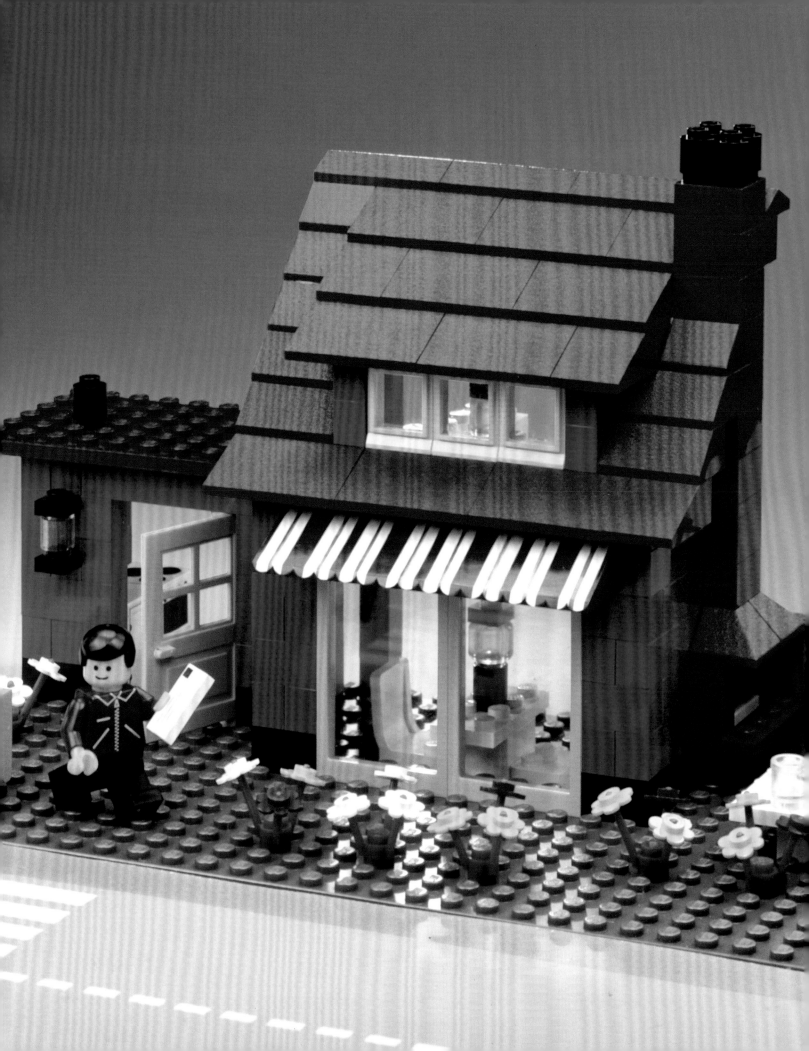

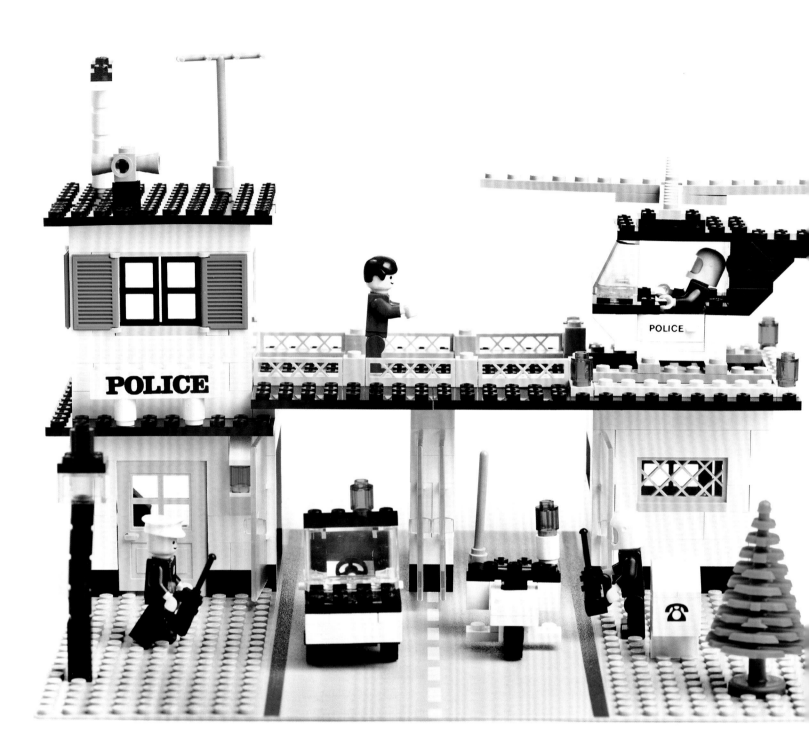

THE ART OF THE MINIFIGURE

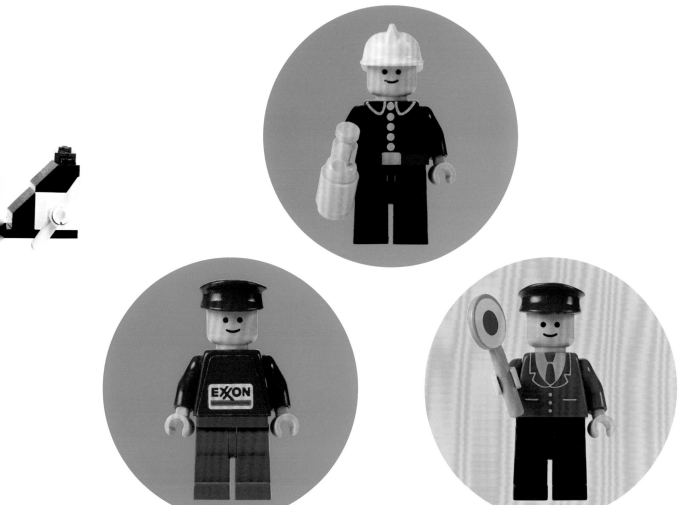

OF ALL THE DECISIONS THAT CHARTED THE MINIFIGURE'S PATH, THE FACE MAY HAVE BEEN THE MOST CONSEQUENTIAL. JUST TWO DOTS AND A SLIGHT SMILE. THAT'S IT. AND WHILE MINIFIGURES WOULD EVENTUALLY GO ON TO EMBRACE A RANGE OF EXPRESSIONS, NOTHING ENCAPSULATES THE LEGO ETHOS QUITE LIKE THOSE HAPPY INHABITANTS OF CASTLE, TOWN, AND SPACE. BETTER STILL? THEY ALIGNED PERFECTLY WITH SYSTEM IN PLAY.

SPACE

The LEGO® Space theme began with just four sets in 1978 in the United States and 1979 in the rest of the world. It is now one of the most expansive themes in LEGO history, with more than 200 sets in forty years.

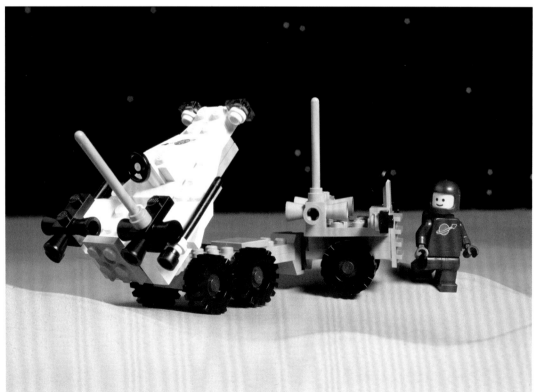

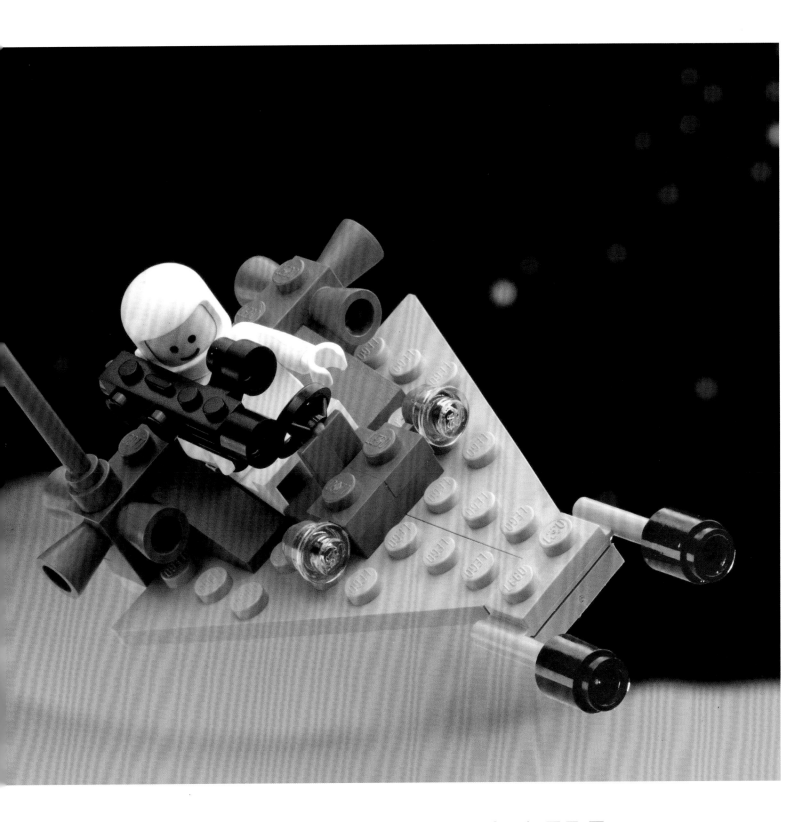

LEGO SPACE MINIFIGURES WERE
DESTINED FOR GREATNESS—AND
THE OUTERMOST REACHES OF OUR
IMAGINATION.

THE SPACE MINIFIGURE

The original minifigures were identical by design: same size, same shape, same two dots and a line for the face. Their differences were a matter of accessory, the bullhorn they came packaged with or the uniform they were assigned. And even those carried over; you can find minifigures donning the exact same helmet in Space, Town, and Castle. It's an intentional uniformity, in its own way an extension of System in Play: Barring thematic inconsistencies, every minifigure fits identically into every situation.

Yet among those minifigure pioneers, the space minifigures stand out. They persist. They owe part of that cross-generational appeal to the sets they appeared in. It's hard to compete with a rocket launcher and a space shuttle. And the future, unbounded by the limitations of the present and past, has infinite inherent appeal.

For a certain generation of LEGO fans, those early Space sets and minifigures are indelible. They steal the show in THE LEGO® MOVIE™, in part because codirector Chris Miller didn't have to look far for inspiration.

"The character in the movie, Benny, the 1980-something space guy, is . . . straight out of my collection," Miller said in a 2014 GQ interview. "I had a blue spaceman that was like the lead of my stories I was telling and he had a cracked helmet and everything."

Then again, maybe it's even simpler than all that. Maybe the space minifigures resonate because nowhere else in those early sets does form so perfectly match function. That small, fixed smile works just fine on a medieval knight or a town constable. But in space, it shines. There's no pure joy like launching rockets on the moon, or riding your own personal space shuttle around the rings of Saturn. The space minifigure is just happy to be there. And so are you.

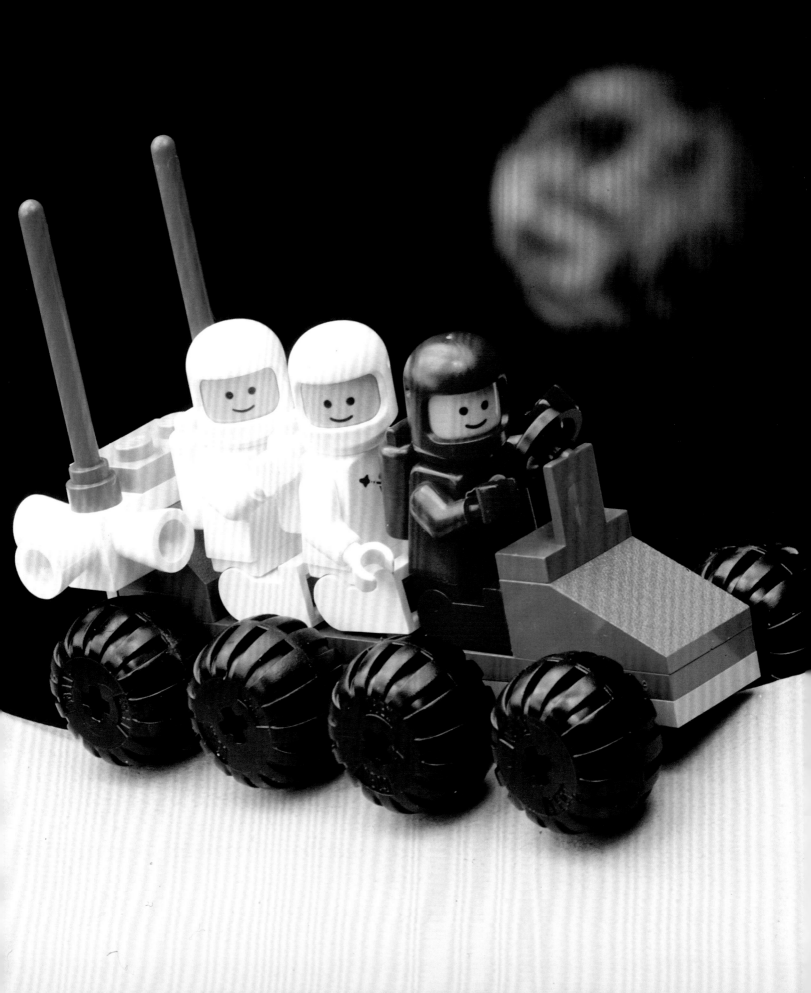

CHAPTER 4

BREAKING THE MOLD

t figures that a pirate would shake things up. Throughout the 1980s, minifigure design remained largely unchanged. Outfits were updated, a few new elements appeared, but they otherwise held steady while the sets around them continued to evolve.

LEGOLAND® Castle, Town, and Space maintained their popularity through the decade. But eventually the time was right to expand, and in 1989 the LEGO Group set sail with its LEGO® Pirates theme. As far as minifigures went, the calculation was simple.

"We can't make pirates without beards," says designer Niels Milan Pedersen. "You can't do that."

And not just beards. The protagonist of the LEGO Pirates set, Captain Redbeard, has a peg leg and a hook for a hand. He even wears an eye patch. In other words, Redbeard laughed in the face of all that was sacrosanct to minifigure modeling.

It's not a decision that the LEGO Group took lightly. Remember that each new body part requires a new mold, adding expense and complexity to a process that had gone unchanged for over a decade. What's more, the Pirates theme introduced the most clearly drawn conflict of any set to date. Captain Redbeard's crew was positioned against the blue-coated soldiers of Governor Broadside.

Credit that decision to Kjeld Kirk Kristiansen, grandson of Ole Kirk and son of Godtfred Kirk, who had become president and CEO of the LEGO Group a decade prior. To stay ahead of the competition, which had invested in fully articulating action figures and other high-tech advances, they needed minifigures to work just a little bit harder. But mostly, if you're going to do pirates, you need to do it right.

You also need to make sure they remain recognizably true to their roots as LEGO elements. Against all odds, they did. Underneath all that new scruff, every pirate minifigure still smiled. Everyone's still just happy to be there. And maybe it wasn't so easy to pinpoint a villain after all. "We watched a lot of old pirate movies growing up," says Niels Milan Pedersen. "The pirates were the good guys!"

The Pirates theme introduced the first LEGO gun element, but also helped codify its rules around weapons. "It needed to be very old-fashioned," says Jan Ryaa. That meant flintlock pistols and muskets. To this day, only fantasy or historical weapons are allowed in the hands of a minifigure.

In the decade after Pirates debuted, minifigures explored all kinds of uncharted waters. But it wasn't until the turn of the millennium that minifigure innovation went into hyperdrive.

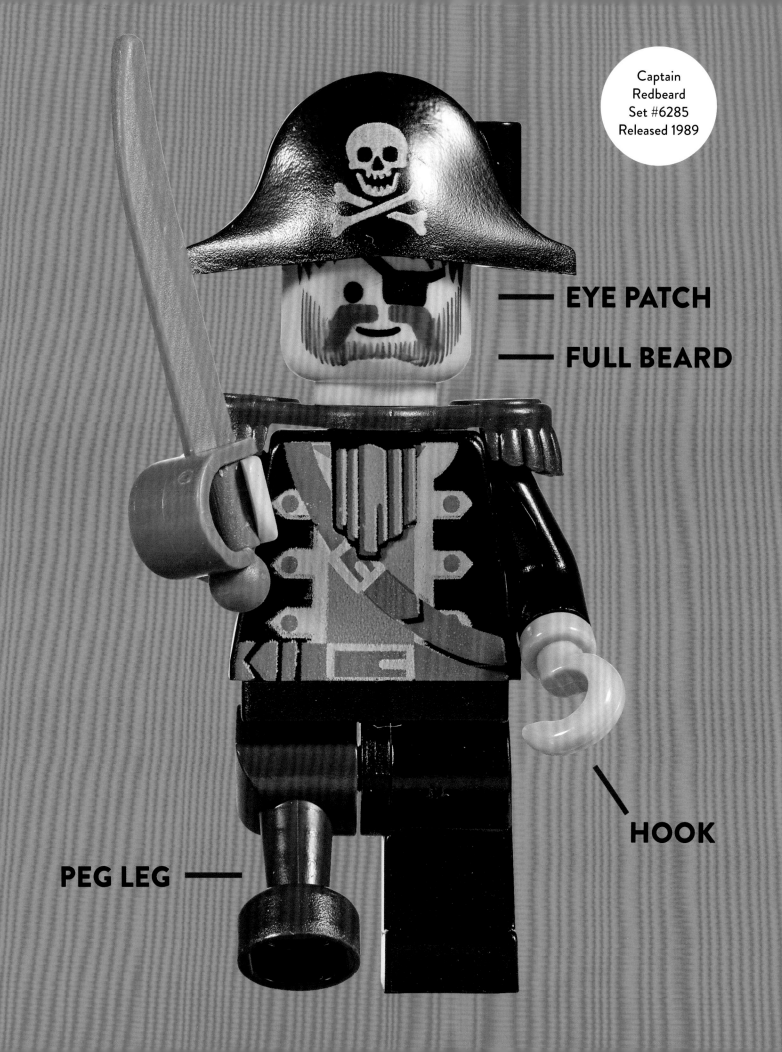

Captain Redbeard
Set #6285
Released 1989

EYE PATCH

FULL BEARD

HOOK

PEG LEG

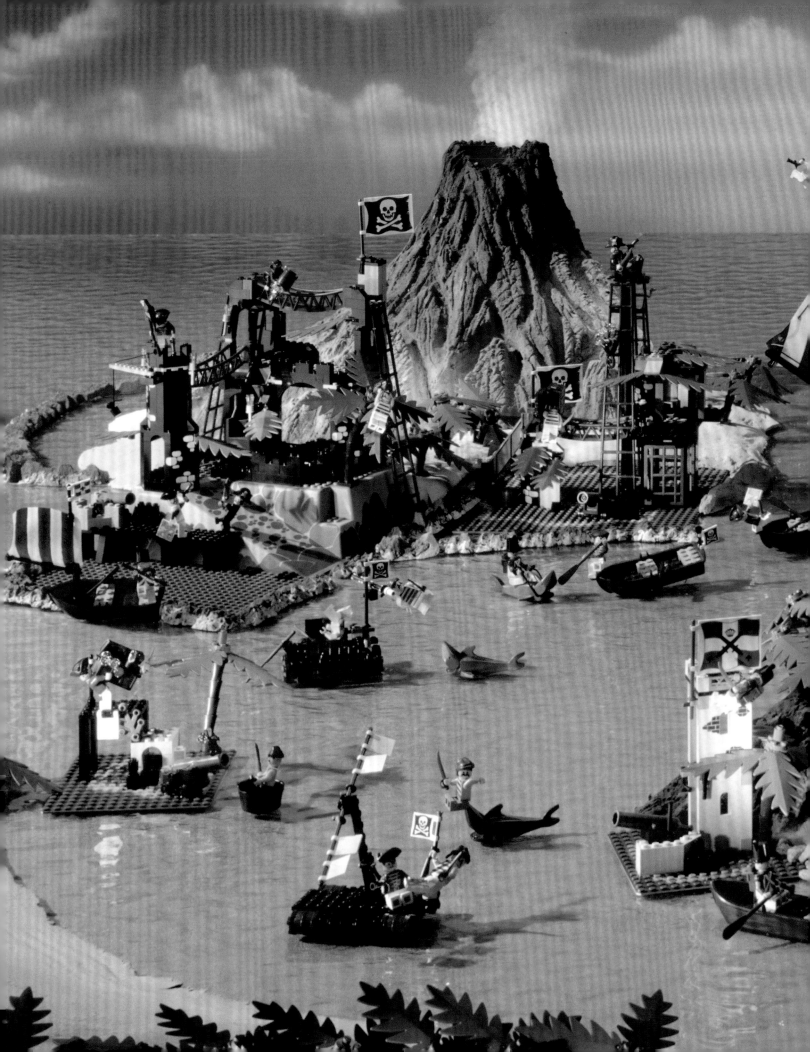

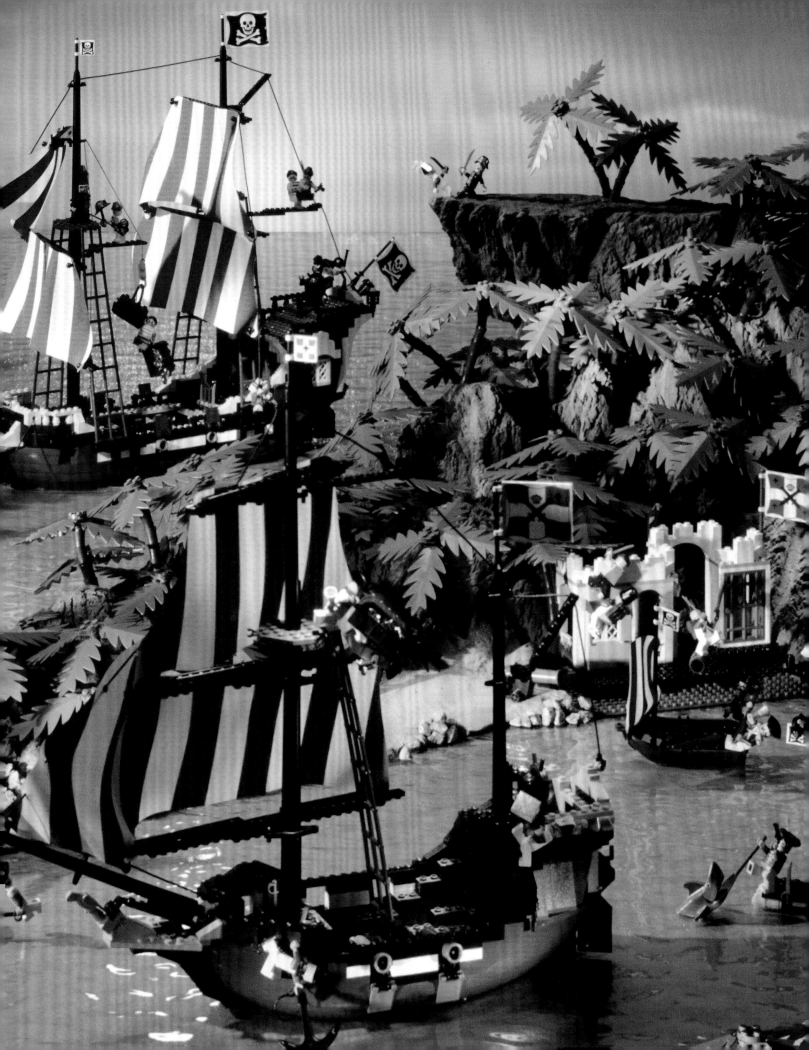

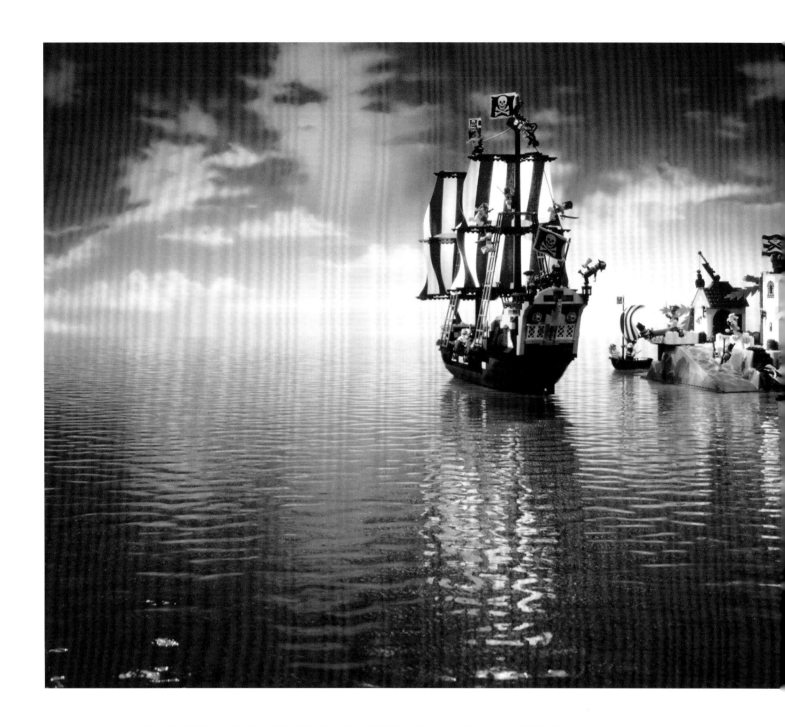

**MINIFIGURES SET SAIL INTO
UNCHARTED WATERS WITH NEW
FACIAL HAIR, EXPRESSIONS,
AND A COMPLEX NARRATIVE. AND
A MONKEY NAMED SPINOZA.**

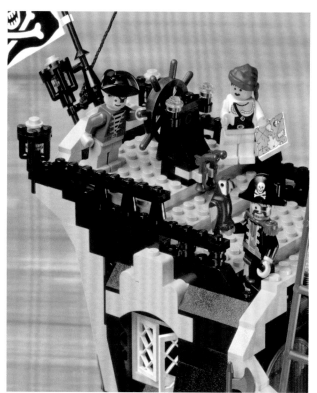

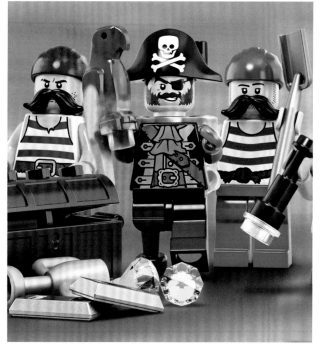

PREVIOUS SPREAD, FAR LEFT, AND ABOVE: The Black Sea Barracuda, set #6285 released in 1989, floats on real water for its brochure photoshoot.

LEFT: In 2020, LEGO® Ideas released a reimagined LEGO Pirates set, #21322 Pirates of Barracuda Bay. In it, the famed Captain Redbeard is discovered after having been stranded on a desert island for twenty years. His graying beard offers a wink to fans of the original 1989 minifigure.

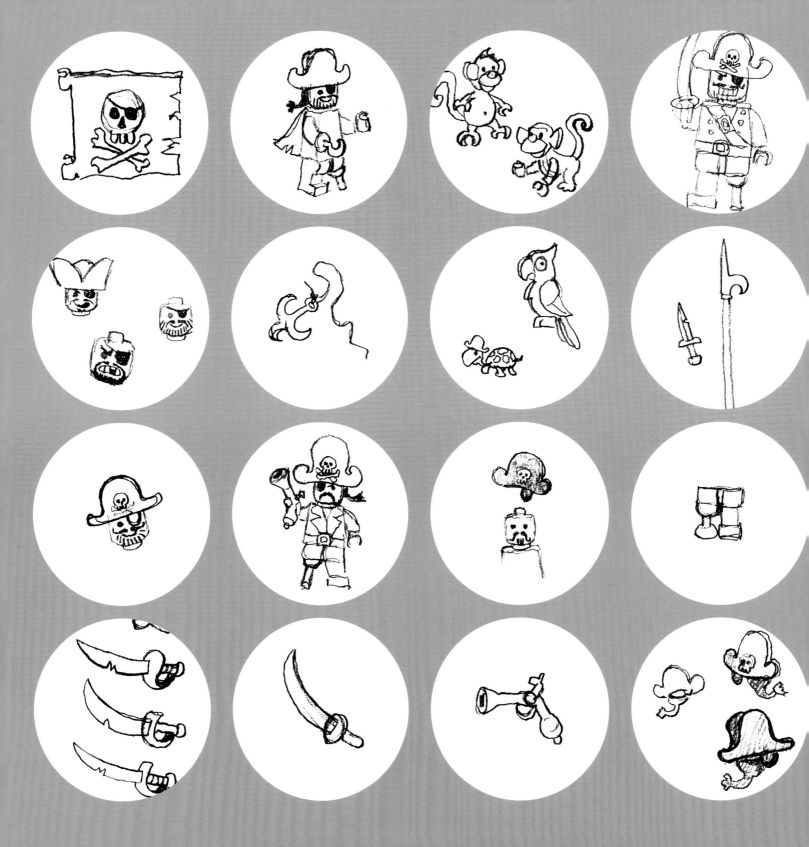

The original sketches for the LEGO Pirate sets represent the first chance designers had to seriously remix the minifigure, plundering their memories of classic films for inspiration. And while they explored some rougher, tougher versions of Captain Redbeard's face and weaponry, it's telling that smiles and simplicity ultimately won out.

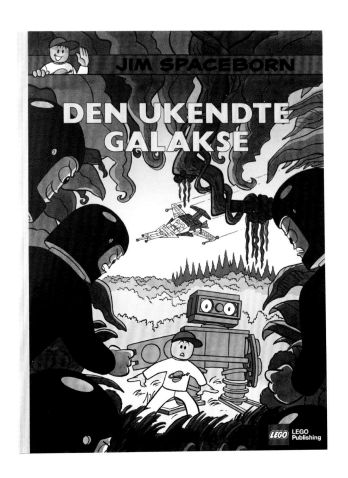

THE BALLAD OF JIM SPACEBORN

Pirates may have been a departure from the original, but the theme had nothing on *Jim Spaceborn*, a graphic novel published by the LEGO Group a few years before Captain Redbeard hit the shelves. If Pirates bent the minifigure rules, *Jim Spaceborn* obliterated them, giving its lead character blasphemous luxuries like fingers and full range of motion. In a way, *Jim Spaceborn* would presage the liberties various LEGO video games and movies would take through the next four decades—until THE LEGO® MOVIE™ set them straight.

MEET THE FIRSTS

THE GHOST
('90)

THE LIPS
(pirate '89)

THE SANTA
('95)

AFTER PIRATES, THE DAM BROKE. NEWLY EMBOLDENED LEGO DESIGNERS CONTINUED TO PUSH THE LIMITS OF WHAT A MINIFIGURE COULD BE AND DO.

THE BEARD
(wizard '93)

THE DRESS
('90)

THE SKELETON
('95*)

(*A decade after his first pitch, Niels Milan Pedersen finally got his skeleton figure.)

THE CLOTH CAPE
(LEGO Castle Royal Knights '93)

THE NOSE
(Time Cruising Timmy '96)

THE CHILD
('09)

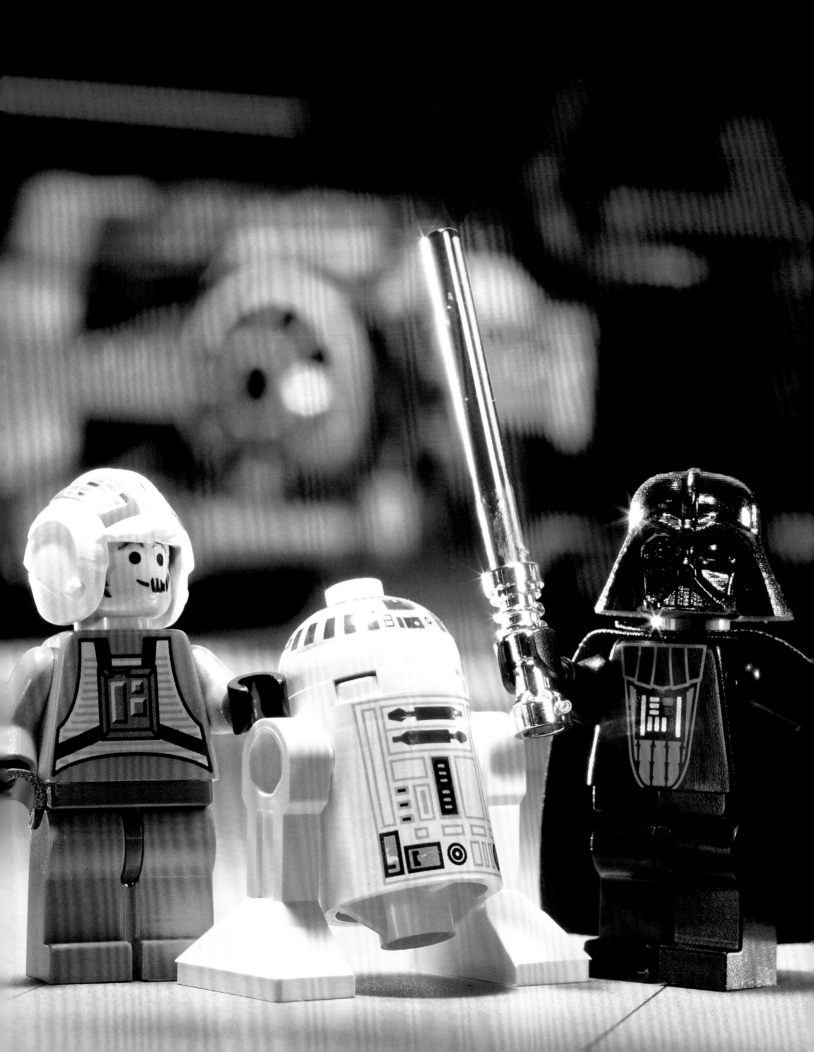

CHAPTER 5

USE THE FORCE

When Jens Kronvold Frederiksen showed up for his first day at work at LEGO® headquarters in 1998, his eye immediately caught something unexpected: sketches of LEGO® *Star Wars™* models.

At the time, the LEGO Group and Lucasfilm—since acquired by Disney—hadn't yet reached an agreement. These were just explorations of what a product line could be. In fact, the very idea of partnering with an outside company felt anathema to many longtime employees. With the exception of a few wooden toys dating back to Ole Kirk's time, the brick house had done it alone.

But it was Ole Kirk's grandson—and Godtfred's son—Kjeld Kirk who decided to let down the drawbridge. The first LEGO *Star Wars* themes launched the following year, inexorably changing the course of the company and spurring previously unthinkable innovation in minifigures.

Jens Kronvold Frederiksen has spent the last twenty years working on the collection, most of it as the design lead. At first, he says, the popularity of the minifigures in those early sets caught the team off guard. That didn't last long.

"We learned very early in the process that they're super important," says Frederiksen. "They *are* the story. If you have a very cool ship, well, it's the character that's flying it. It's the main character of the movie. It's something special here."

A truck driver in a LEGO® City theme is, well, a truck driver. But Luke Skywalker is a hero. Darth Vader is an icon. Jar Jar Binks is . . . complicated. In fact, from a design perspective, they are all complicated in their own way, especially given the design limitations of minifigures at the time when *Star Wars* sets were first introduced.

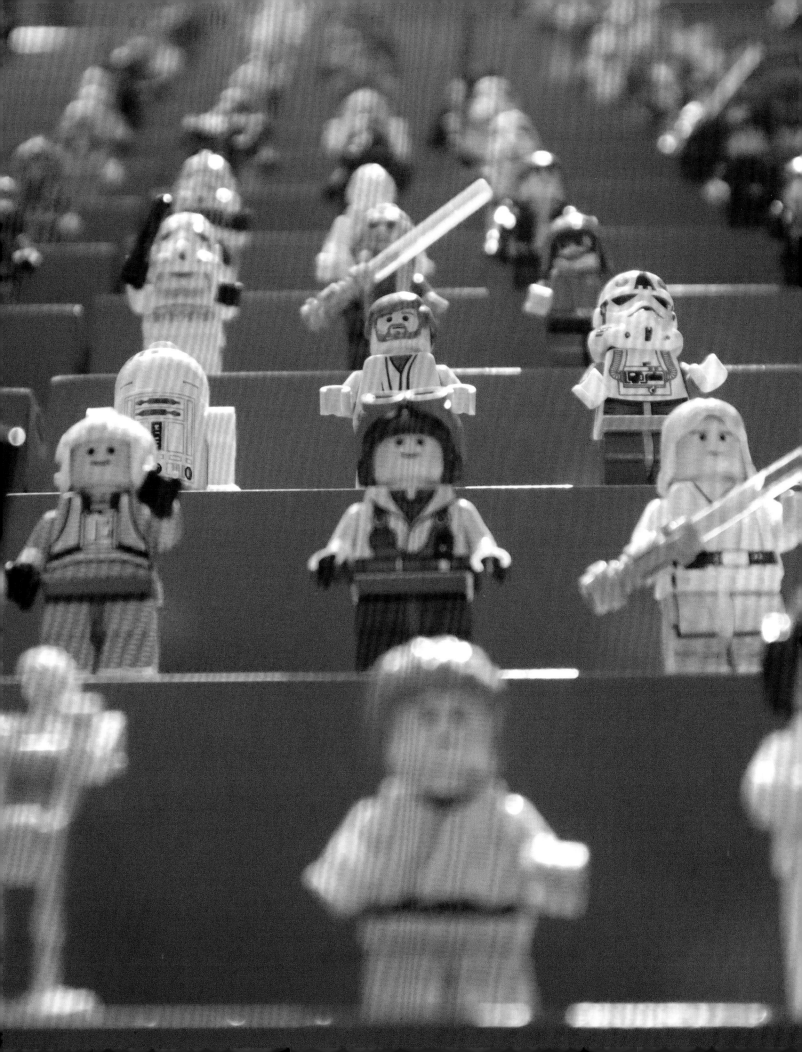

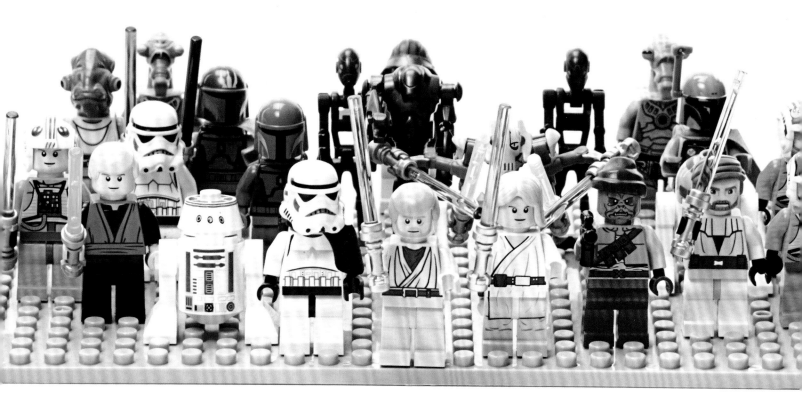

Take something as seemingly simple as hair. "At that time we only had one wig, as we call it. It's the Roy Orbison hair; it's super flat with a side part and really, really shiny," says Jens Kronvold Frederiksen. "So when we created the first LEGO *Star Wars* minifigures, we used that hairpiece. For Luke it was blonde, it was brown for Han, and so on. Then we said, okay, this doesn't work for any character."

And so, for the first time, LEGO designers sculpted a new hairpiece, to fit the Qui-Gon Jinn minifigure. The seemingly simple accommodation had an incalculable ripple effect. "That kind of set the standard for a lot of other licensed themes but also our internal themes," says Frederiksen. "It's suddenly okay to mess with the hair on the minifigure."

More than just hair. The story of LEGO *Star Wars* minifigures is one of not breaking the mold, but creating altogether new ones. The first minifigure head to depart from the standard yellow cylinder? Jar Jar Binks. To create

Chewbacca, the LEGO team made a special extended headpiece to mimic the appearance of fur on the Wookiee's front and back.

Thanks in part to System in Play, minifigure innovations don't stay self-contained for long. Once new hair, new heads, and new legs enter the scene, they make their way into every set—when appropriate. More importantly, the minifigure's primacy in play began to permeate other themes as well.

"In the beginning we didn't have a lot of focus on the minifigure. We had this mantra that said that the model was king," says Karsten Juel Bunch, who served as creative lead for the LEGO City line. "And then gradually we started to evolve, we got more and more focused on the minifigure. *Star Wars* had a big influence."

**LUKE
SKYWALKER**

HAN SOLO

"DOING SOMETHING WHERE YOU'RE CHANGING THE PROPORTIONS . . . THAT'S A BIG DEAL . . . BUT IN *STAR WARS*, IF YODA IS THE SAME SIZE AS DARTH VADER, IT DOESN'T WORK."
—JENS KRONVOLD FREDERIKSEN, LEAD DESIGNER, LEGO *STAR WARS*

SHORT —— NONPOSABLE LEGS

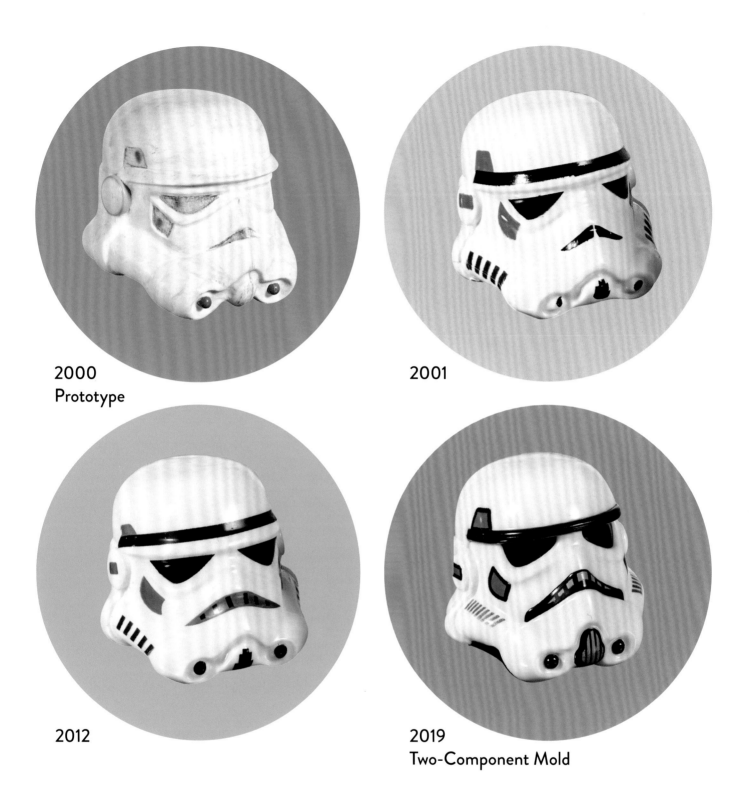

2000
Prototype

2001

2012

2019
Two-Component Mold

ABOVE: LEGO designers will continue to refresh a *Star Wars* minifigure design when a technological or artistic breakthrough allows for it. A recent stormtrooper overhaul takes advantage of a relatively new two-component molding process, which allows for two colors to be rendered in plastic in the same design. It improves colorfastness and detail versus a more traditional printed graphic. One minifigure that has remained unchanged since its debut: Greedo.

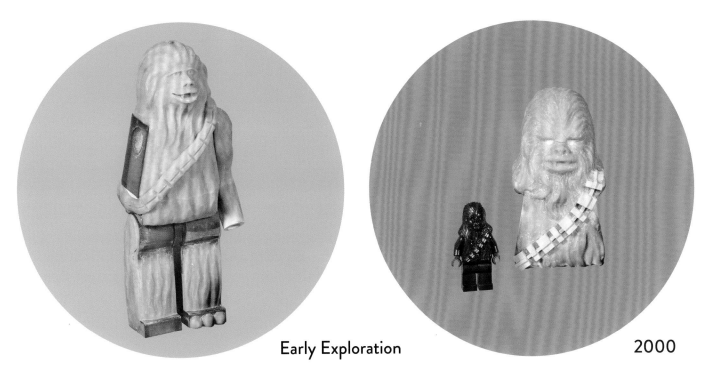

Early Exploration

2000

1999

While digital modeling software like ZBrush has become increasingly popular among LEGO designers, polymer clay still gets plenty of use. That applies doubly when it comes to more organic elements like hair, where gravity helps give design cues of how it might fall in real life.

FOR THE FIRST TIME, LEGO DESIGNERS SCULPTED A NEW HAIRPIECE, TO FIT THE QUI-GON JINN MINIFIGURE. THE SEEMINGLY SIMPLE ACCOMMODATION HAD AN INCALCULABLE RIPPLE EFFECT.

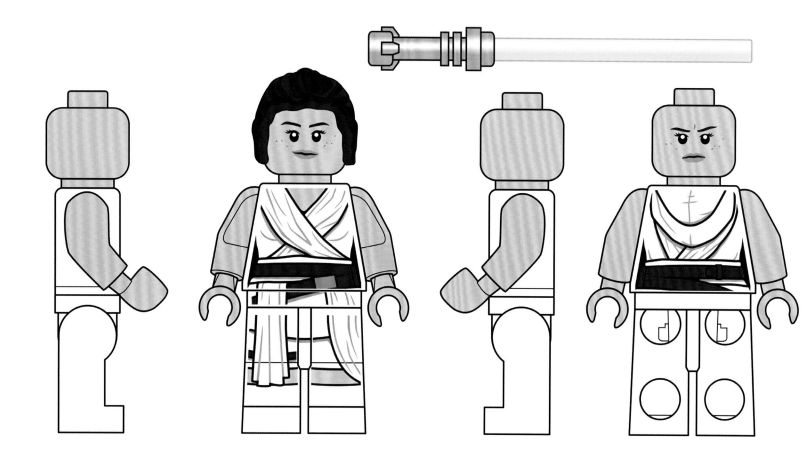

CHARACTER DESIGN SHEETS GIVE A
360-DEGREE BREAKDOWN OF EVERY
MINIFIGURE, DOWN TO THEIR COLOR
PALETTE AND ALTERNATE FACE. WHEN
IT COMES TO PRECISION, THERE IS
NO TRY.

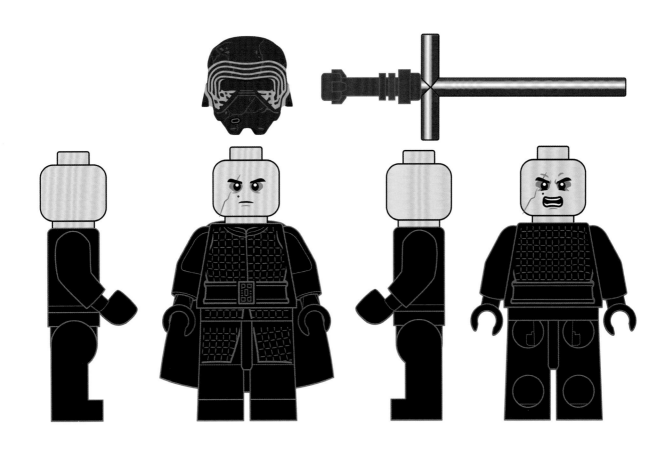

USE THE FORCE

Star Wars was the first licensing partner to spur major minifigure innovation, but it was hardly the last. Matching Professor Quirrell/ Voldemort's two heads in LEGO® Harry Potter™ required a new printing process in 2001, which in turn opened up a world in which minifigures could switch between two moods with a twist of the noggin. They even made a glow-in-the-dark head for Professor Snape. And a 2003 partnership with the National Basketball Association ushered in realistic skin tones for the first time. From 2003 onward, yellow minifigures were used for unique LEGO themes such as LEGO® City, LEGO® NINJAGO® and LEGO® Creator, while minifigures with skin tones appeared in licensed themes, and wherever real-life people were being represented, such as in the Women of NASA set, or characters from movies, literature, or TV shows like Marvel Super Heroes™, Star Wars™, or Harry Potter™.

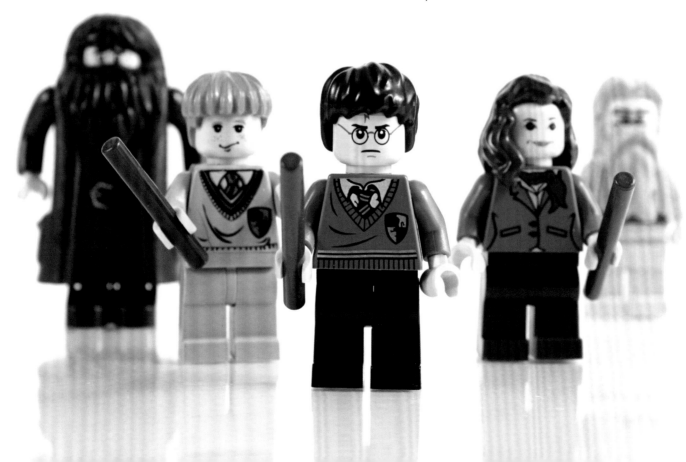

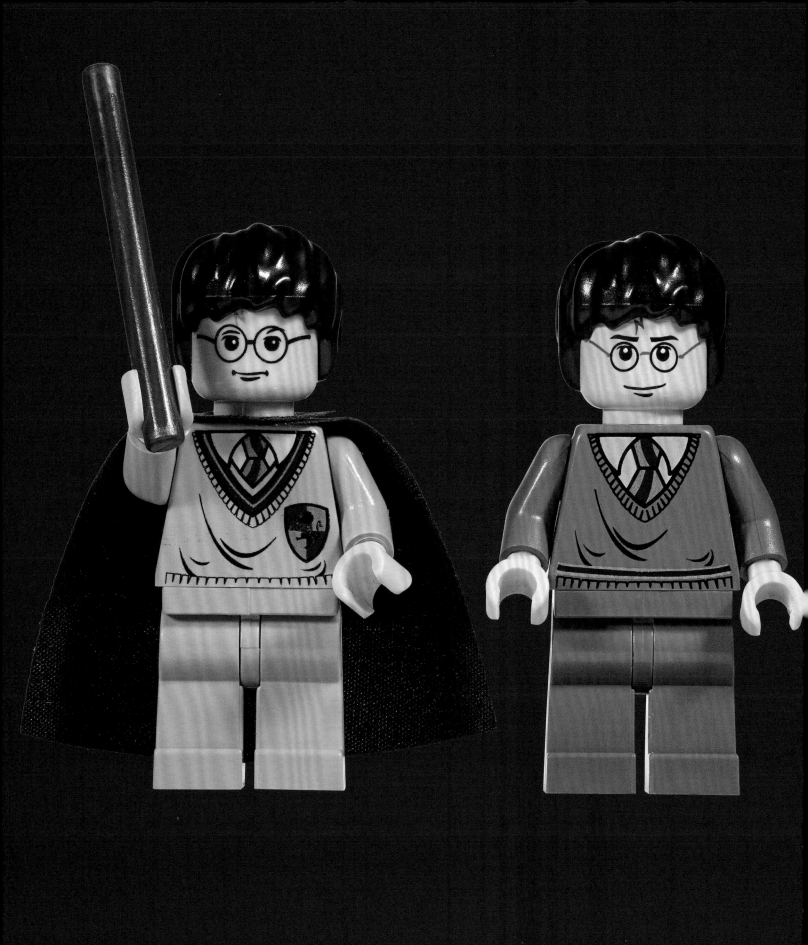

THE INTRODUCTION OF SKIN
TONES WAS A STARK DEPARTURE
AFTER DECADES OF YELLOW.
BUT IT'S HARD TO ARGUE WITH
THE RESULT: MINIFIGURES THAT
LEVEL UP SIGNIFICANTLY IN BOTH
VARIETY AND LEVEL OF DETAIL.

The success of LEGO *Star Wars* and other licensed lines influenced the minifigure's role across homegrown themes as well. "In the beginning we just wanted to have a fire truck," says former LEGO City creative lead Karsten Juel Bunch. "In the end, we wanted a story with a fire truck as part of it. The minifigure becomes much more of a pinnacle in the development of all the models."

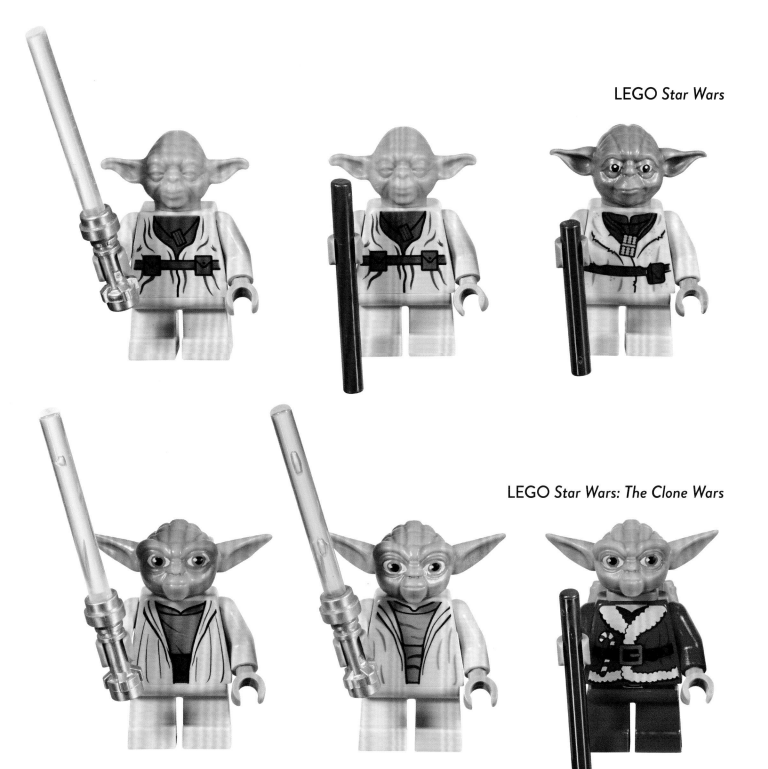

LEGO *Star Wars*

LEGO *Star Wars: The Clone Wars*

POP CULTURE FOREVER TRANSFORMED THE MINIFIGURE'S ROLE. STILL, THE LEGO GROUP WAS ESSENTIALLY MAKING MINIFIGURES FOR OTHER PEOPLE. THE MINIFIGURE'S ASCENT WOULDN'T BE COMPLETE UNTIL THE LEGO GROUP STARTED MAKING THEM FOR ITSELF.

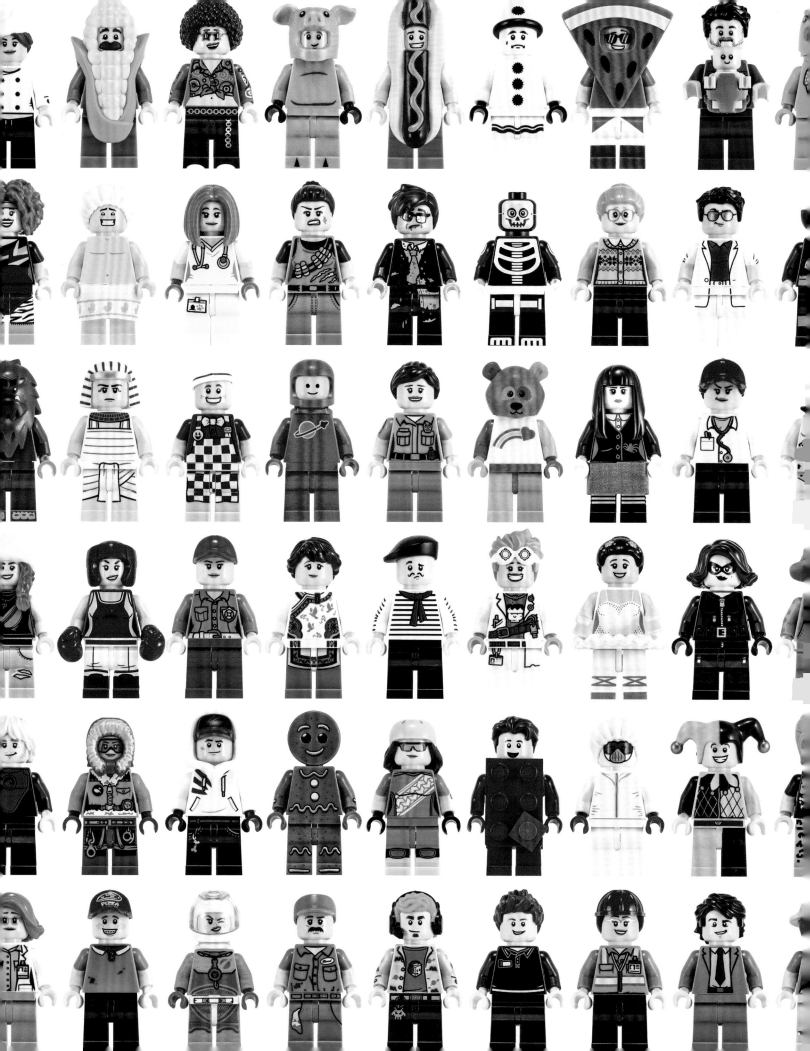

CHAPTER 6

SERIES 1

I n 2000, just a year after the launch of LEGO® *Star Wars*™, a newly hired designer named Matthew Ashton showed up at a freewheeling brainstorming session ready to present. His idea: a collectible line of minifigures.

"I was pretty much laughed out of the room," says Ashton today. Management hadn't considered selling products that didn't contain LEGO bricks before.

At the time, minifigures still took a back seat to the play sets. LEGO *Star Wars* had started to show glimpses of their broader potential, but not to the point that the LEGO Group was willing to give them that bright a spotlight. The company had invested in larger, more fully featured action figures, like the Jack Stone line that would hit the shelves in 2001.

Ashton himself was working on the since-retired LEGO® Clikits arts and crafts line, meaning he had no direct input on how minifigures were used in popular themes. Still, he and other designers felt that they were ready for center stage.

"When I was a child I absolutely loved minifigures," says Ashton. "I had such an emotional attachment with something that wasn't really given a lot of personality, but I just found the proportions and the articulation and how colorful they were so cute and appealing."

In 2005, Ashton transitioned off of Clikits to work on what the company considered boy-focused product lines like LEGO® Aqua Raiders,

LEGO® Agents, and LEGO® Castle. He quickly focused on bringing minifigures up to speed—a process that required a fundamental shift in perspective. "I was really adamant that we needed to do something to firstly invest in giving the minifigures the right number of accessories, and the right headgear, so that they became individual characters in themselves that were really iconic and recognizable," says Ashton. "They could become little story starters in a way."

Matthew Ashton was convinced that by investing in minifigures, creating all-new, fully realized iconic characters, the company could spark the imaginations of children who had already exhausted their prescribed sets. A clown minifigure might just inspire you to reach into your bin of bricks to build a circus. "It really was highlighting that, yes, providing LEGO characters would very much spark their imagination, and encourage building and creativity."

But first, the team had to codify the boundaries of the minifigure's design. In the early years, that hadn't been an issue; the sameness was the point. But the experimentation of the 1990s and 2000s had bred an inconsistency that threatened to spiral out of control. "We went from having the retro-faced minifigure that's just two dots and a smile to different expressions," says senior design manager Tara Wike. "There was lots of freedom among the product teams about how they should look. There wasn't a lot of alignment

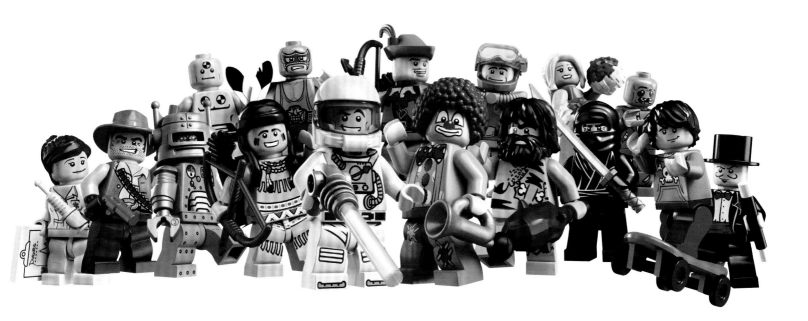

or control over the styling."

So in 2009, Ashton and Wike began the laborious process of writing out the dos and don'ts of minifigures. They gathered input from the legal team, and illustrators and animators, and anyone else who had a stake in protecting and preserving the minifigure's look. It took about a year to assemble the 300-page tome, but eventually they had it: *The Complete LEGO® Minifigure Guidelines*, also known as the Big Yellow Book.

The exact contents of the Big Yellow Book are closely guarded, for obvious competitive reasons. But suffice to say, it's comprehensive, offering designers guidance on everything from navel placement to the shape, positioning, and highlighting of the eyes. Some exceptions are made, especially for pop culture doppelgangers— Emperor Palpatine's eyes, for instance, defy minifigure orthodoxy—but homegrown themes should stay within the framework.

Armed with the Big Yellow Book, the broader embrace of the minifigure sparked by LEGO *Star Wars* and other pop culture tie-ins, and a long overdue shift in perspective that put the minifigure at the center of the play experience, Ashton again pitched his collectibles line a decade after his first attempt. This time, it worked.

The first Collectible LEGO® Minifigure

Series hit US stores in June 2010, in a packaging largely unfamiliar to that audience. In Europe, Matthew Ashton had grown up with so-called blind bag collectibles, packaging that hid what specific item of a set was inside. But US retailers blanched at the idea, concerned that they'd experience high return rates, or that people would try to rip the bags open in the store. Instead, customers bought them in droves.

In the decade since, that effort has born over 500 characters between the main Collectible Minifigure line and various spin-off series for Disney, the LEGO movies, and beyond. The original inventions live across a total of twenty-two series (and counting), encompassing everything from a nurse to a monkey king. All these years later, they're still pulling ideas from that original list.

What goes into each line isn't an exact science, but the team does try to make sure each series contains a diverse array of characters. "We'd try to make sure we had an athlete, a historical character, a fantasy character, a silly character," says Tara Wike.

But however wild the imagination runs in generating minifigures, the end result has to fall within the agreed-upon framework. This is the LEGO Group, after all.

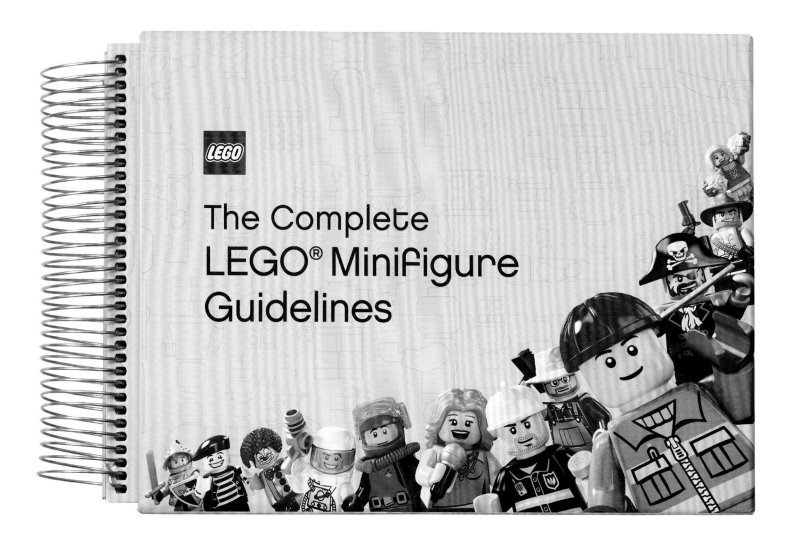

The Complete LEGO® Minifigure Guidelines

Before the Big Yellow Book,
designers sometimes took liberties
with the iconic minifigure. Today,
every character has to align with
the principles it lays out—right
down to the chest hair.

DESIGN OF ELEMENTS IN THE GRID

Accessories can be designed in both orientations of the grid. The element's directionality is determined by what makes the most sense from a functional and building standpoint. A sword, for example, is most likely held in a vertical position by the minifigure and in models, whereas a gun is used in a horizontal direction.

Headgear and wigs are always designed around the head of the minifigure, and are thus positioned in the grid in relation to the minifigure, as shown. It is important that the outer dimensions of an element do not extend outside the grid lines, as they will not fit into models correctly. Allow sufficient clearance between an element and the grid edge.

Connectors must always be in the correct place, like here on this vest, in case the element is to be used other than on the body of a minifigure.

The diver's suit below is a good example of a grid-designed element, allowing it to fit into the snuggest of submarine compartments. It also has various grid-aligned connectors that allow it to be integrated into a model as detailing. As is the aim with most LEGO® elements, the suit has a multitude of uses.

Designers use many methods to sculpt new LEGO elements, but the end result is always designed to work within the LEGO system grid. Everything needs to fit like peas in a pod.

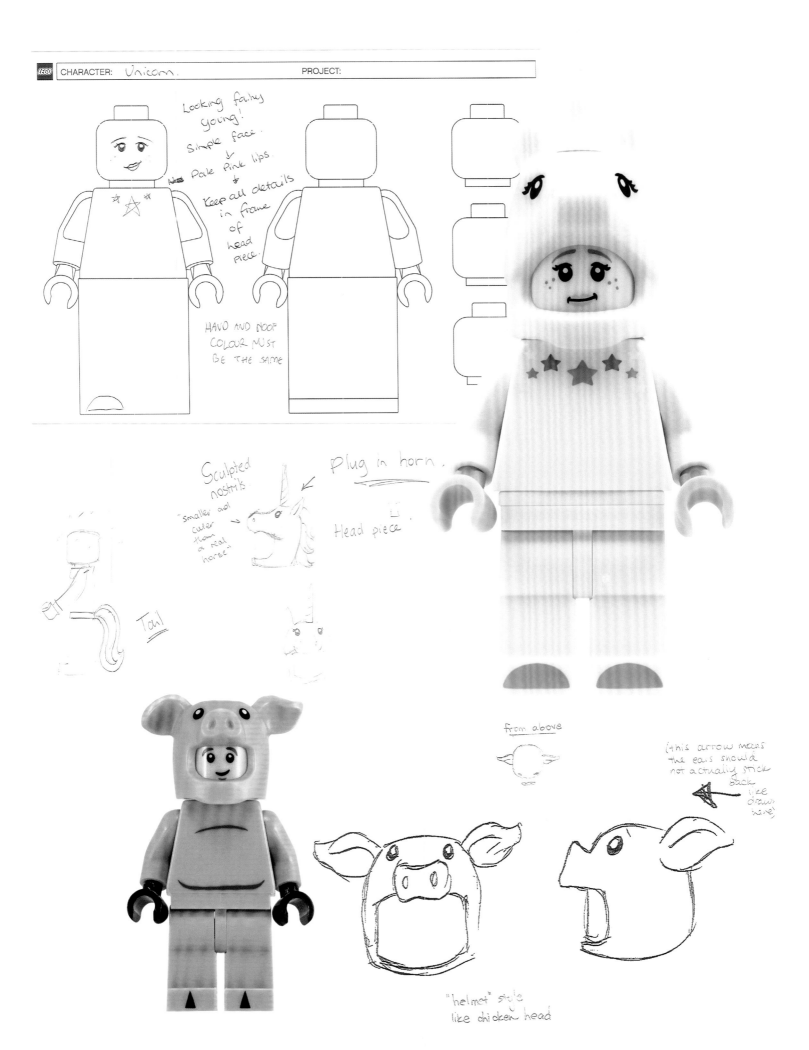

CHARACTER: Unicorn. PROJECT:

Looking fairly young! Simple face. → Pale Pink lips. → Keep all details in frame of head piece.

HAND AND HOOF COLOUR MUST BE THE SAME

Sculpted nostrils. "smaller and cuter than a real horse"

Plug in horn.

Head piece.

Tail

from above

(this arrow means the ears should not actually stick back like drawn here)

"helmet" style like chicken head

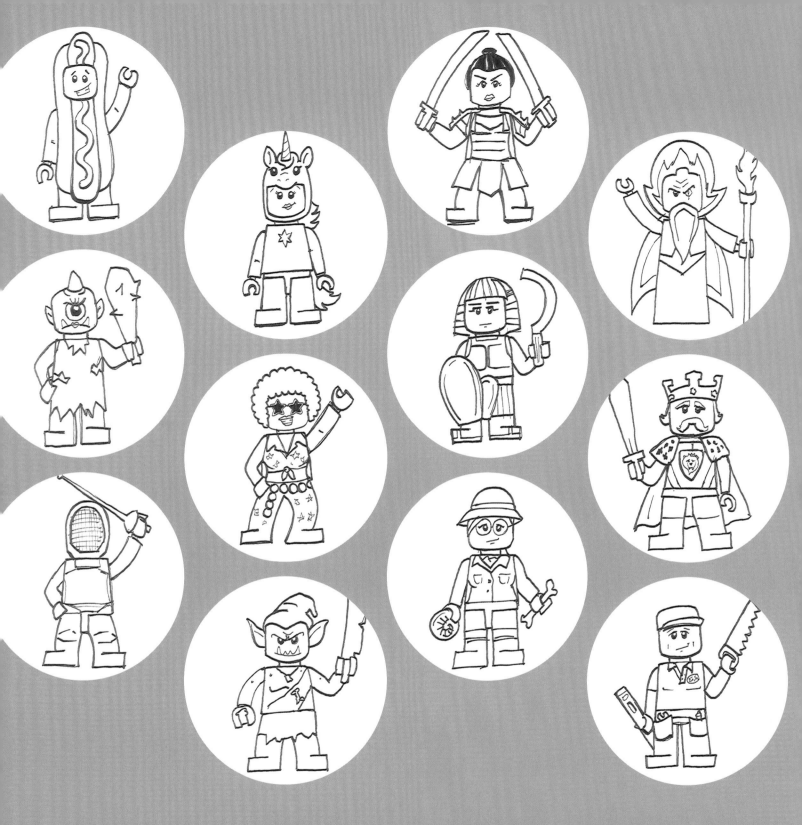

LEFT AND ABOVE: Before launching the Collectible Minifigure Series, Matthew Ashton led a character brainstorming session that yielded a list of hundreds of ideas, many of which have since been brought to life. "You've got a whole department of people bursting with characters that they've always wanted to create that have never been available," Ashton says. "So we got the wisdom of the crowd to see how far we could go with this." Sketches by Matthew Ashton.

"EVERYBODY'S GOT A PASSION POINT OR A HOBBY, OR SOMETHING THAT THEY WANT TO SEE REFLECTED IN A MINIFIGURE." —MATTHEW ASHTON, VICE PRESIDENT OF DESIGN

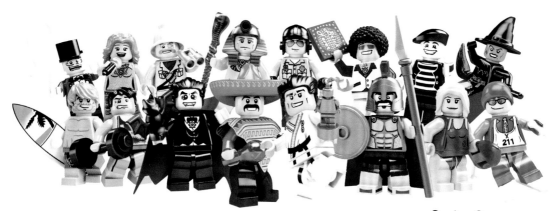

Series 2

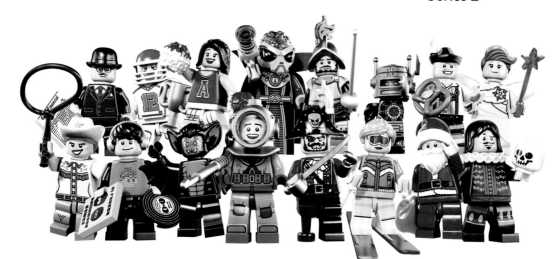

Series 8

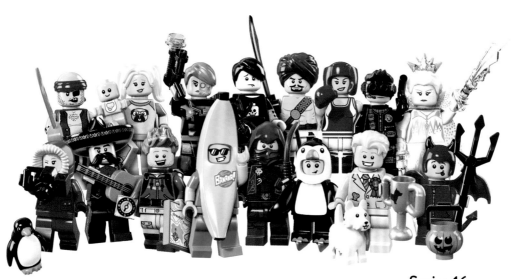

Series 16

The Collectible LEGO Minifigure Series has exponentially expanded the LEGO universe of characters. Sketches by Alexandre Boudon, concept design master.

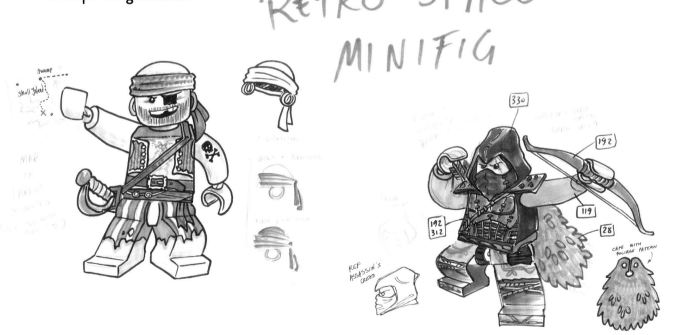

TEN YEARS OF THE COLLECTIBLE LEGO® MINIFIGURE SERIES

☐ Tribal Hunter	☐ Cheerleader	☐ Caveman	☐ Circus Clown	☐ Zombie	☐ Skater
☐ Robot	☐ Demolition Dummy	☐ Magician	☐ Super Wrestler	☐ Nurse	☐ Ninja
☐ Spaceman	☐ Forestman	☐ Deep Sea Diver	☐ Cowboy	☐ Maraca	☐ Spartan Warrior
☐ Ringmaster	☐ Witch	☐ Vampire	☐ Traffic Cop	☐ Explorer	☐ Lifeguard
☐ Mime	☐ Weight Lifter	☐ Pop Star	☐ Skier	☐ Disco Dude	☐ Karate Master
☐ Surfer	☐ Pharaoh	☐ Fisherman	☐ Pilot	☐ Tribal Chief	☐ Samurai Warrior
☐ Snowboarder	☐ Space Villain	☐ Sumo Wrestler	☐ Mummy	☐ Elf	☐ Tennis Player
☐ Race Car Driver	☐ Gorilla Suit Guy	☐ Space Alien	☐ Hula Dancer	☐ Rapper	☐ Baseball Player
☐ Lawn Gnome	☐ Kimono Girl	☐ Musketeer	☐ Punk Rocker	☐ Surfer Girl	☐ Viking
☐ The Monster	☐ Hockey Player	☐ Street Skater	☐ Sailor	☐ Soccer Player	☐ Werewolf
☐ Hazmat Guy	☐ Artist	☐ Ice Skater	☐ Crazy Scientist	☐ Graduate	☐ Gladiator
☐ Royal Guard	☐ Eskimo	☐ Cave Woman	☐ Lizard Man	☐ Zookeeper	☐ Lumberjack
☐ Small Clown	☐ Fitness Instructor	☐ Detective	☐ Evil Dwarf	☐ Boxer	☐ Egyptian Queen
☐ Gangster	☐ Snowboarder Guy	☐ Classic Alien	☐ Highland Battler	☐ Sleepyhead	☐ Lady Liberty
☐ Bandit	☐ Flamenco Dancer	☐ Clockwork Robot	☐ Minotaur	☐ Leprechaun	☐ Roman Soldier
☐ Surgeon	☐ Skater Girl	☐ Intergalactic Girl	☐ Butcher	☐ Mechanic	☐ Genie
☐ Swimming Champion	☐ Aztec Warrior	☐ Bunny Suit Guy	☐ Bride	☐ Ocean King	☐ Bagpiper
☐ Daredevil	☐ Galaxy Patrol	☐ Tennis Ace	☐ Jungle Boy	☐ Hippie	☐ Computer Programmer
☐ Viking Woman	☐ Evil Knight	☐ Rocker Girl	☐ Grandma Visitor	☐ Evil Robot	☐ Conquistador
☐ Lederhosen Guy	☐ Cowgirl	☐ Football Player	☐ Diver	☐ Downhill Skier	☐ Businessman
☐ Fairy	☐ Santa Claus	☐ Vampire Bat	☐ DJ	☐ Red Cheerleader	☐ Thespian
☐ Pirate Captain	☐ Alien Villainess	☐ Waiter	☐ Cyclops	☐ Hollywood Starlet	☐ Heroic Knight
☐ Roman Emperor	☐ Policeman	☐ Chicken Suit Guy	☐ Roller Derby Girl	☐ Fortune Teller	☐ Judge
☐ Alien Avenger	☐ Mermaid	☐ Battle Mech	☐ Mr. Good and Evil	☐ Forest Maiden	☐ Plumber
☐ Librarian	☐ Medusa	☐ Roman Commander	☐ Warrior Woman	☐ Tomahawk Warrior	☐ Skydiver
☐ Bumblebee Girl	☐ Grandfather	☐ Paintball Player	☐ Sea Captain	☐ Sad Clown	☐ Revolutionary Soldier

☐ Baseball Fielder	☐ Trendsetter	☐ Decorator	☐ Motorcycle Mechanic	☐ Mr. Gold	☐ Barbarian
☐ Scarecrow	☐ Pretzel Girl	☐ Evil Mech	☐ Island Warrior	☐ Gingerbread Man	☐ Holiday Elf
☐ Yeti	☐ Mountain Climber	☐ Welder	☐ Scientist	☐ Saxophone Player	☐ Diner Waitress
☐ Grandma	☐ Constable	☐ Lady Robot	☐ Wizard	☐ Hun Warrior	☐ Fairytale Princess
☐ Video Game Guy	☐ Battle Goddess	☐ Space Miner	☐ Life Guard	☐ Prospector	☐ Jester
☐ Dino Tracker	☐ Pizza Delivery Man	☐ Rock Star	☐ Swashbuckler	☐ Piggy Guy	☐ Genie Girl
☐ Spooky Girl	☐ Classic King	☐ Sheriff	☐ Unicorn Girl	☐ Snake Charmer	☐ Goblin
☐ Paleontologist	☐ Alien Trooper	☐ Egyptian Warrior	☐ Carpenter	☐ Evil Wizard	☐ Fencer
☐ Samurai	☐ Disco Diva	☐ Hot Dog Guy	☐ Lady Cyclops	☐ Galaxy Trooper	☐ Wolf Guy
☐ Zombie Pirate	☐ Monster Scientist	☐ Wacky Witch	☐ Plant Monster	☐ Fly Monster	☐ Specter
☐ Zombie Cheerleader	☐ Tiger Woman	☐ Gargoyle	☐ Skeleton Guy	☐ Monster Rocker	☐ Zombie Businessman
☐ Banshee	☐ Square Foot	☐ Spider Lady	☐ Farmer	☐ Astronaut	☐ Frightening Knight
☐ Clumsy Guy	☐ Tribal Woman	☐ Flying Warrior	☐ Faun	☐ Animal Control	☐ Janitor
☐ Ballerina	☐ Laser Mech	☐ Kendo Fighter	☐ Shark Suit Guy	☐ Wrestling Champion	☐ Jewel Thief
☐ Queen	☐ Ice Queen	☐ Desert Warrior	☐ Cyborg	☐ Cute Little Devil	☐ Spooky Boy
☐ Hiker	☐ Wildlife Photographer	☐ Kickboxer	☐ Scallywag Pirate	☐ Penguin Boy	☐ Rogue
☐ Dog Show Winner	☐ Mariachi	☐ Spy	☐ Banana Guy	☐ Babysitter	☐ Pro Surfer
☐ Strongman	☐ Gourmet Chef	☐ Corn Cob Guy	☐ Veterinarian	☐ Hot Dog Vendor	☐ Butterfly Girl
☐ Roman Gladiator	☐ Connoisseur	☐ Battle Dwarf	☐ Retro Space Hero	☐ Yuppie	☐ Rocket Boy
☐ Dance Instructor	☐ Elf Maiden	☐ Highwayman	☐ Elephant Girl	☐ Brick Suit Guy	☐ Brick Suit Girl
☐ Party Clown	☐ Firework Guy	☐ Birthday Party Girl	☐ Dragon Suit Guy	☐ Classic Police Officer	☐ Spider Suit Boy
☐ Birthday Cake Guy	☐ Cactus Girl	☐ Cat Costume Girl	☐ Race Car Guy	☐ Flowerpot Girl	☐ Cowboy Costume Guy
☐ Birthday Party Boy	☐ Unicorn Guy	☐ Video Game Champ	☐ Shower Guy	☐ Fright Knight	☐ Monkey King
☐ Programmer	☐ Mummy Queen	☐ Jungle Explorer	☐ Fire Fighter	☐ Dog Sitter	☐ Pizza Costume Guy
☐ Galactic Bounty Hunter	☐ Gardener	☐ Rugby Player	☐ Fox Costume Girl	☐ Bear Costume Guy	☐ Mountain Biker
☐ Piñata Boy	☐ Hip Hop Girl	☐ Peapod Costume Girl	☐ Knight	☐ Pirate	☐ Rocket Girl
☐ Llama Costume Girl	☐ Viking	☐ Red Ranger	☐ Nunchaku Fighter	☐ Field Athlete	☐ Diver
☐ Green Brick Suit Guy	☐ Electronic Musician	☐ Sleepy Girl	☐ Drone Pilot	☐ Paddle Surfer	☐ Violin Kid
☐ Shipwreck Survivor	☐ Ladybug Girl	☐ Pug Costume Guy	☐ Centaur Warrior	☐ Beekeeper	☐ Ancient Warrior
☐ Airplane Girl	☐ Space Police Guy	☐ Alien	☐ Cabaret Singer		

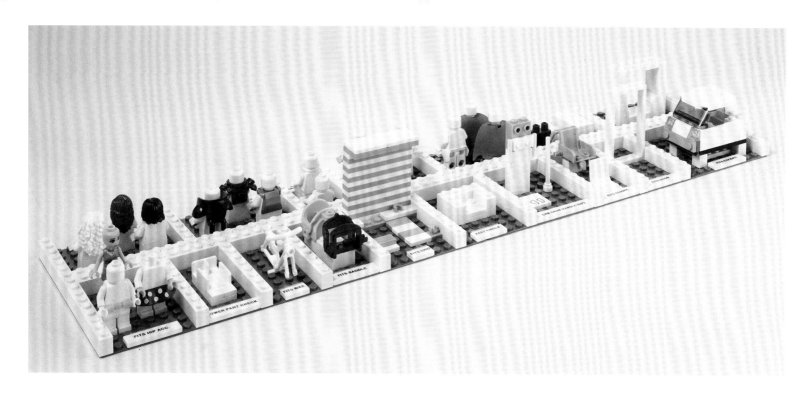

ENTER THE GAUNTLET

Before they can enter production, every minifigure must first pass through "the gauntlet." The simple series of tests ensures that each character fits the System in Play. Can it walk through a door? Fit in a saddle? A cockpit? Can it grab handles? What about with its hand at a 90-degree angle? A minifigure doesn't actually have to be able to *do* all of these things; poor Corn Cob Guy isn't flying a LEGO plane anytime soon. What matters is whether it's immediately clear that a minifigure can pull off a given task or not. If it's too hard to tell either way from a glance, it's back to the modeling software.

The development of / Udviklingen af

LEGO® MINIFIGURES FIGURE 04, CORN COB GUY 2017

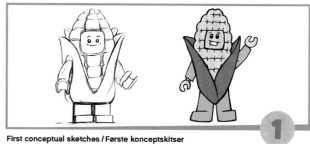

First conceptual sketches / Første konceptskitser
Hand drawings / håndtegninger

1

Development / Udvikling
Clay sculptures & 3D computer models / Lerskulpturer & 3D computermodeller

2

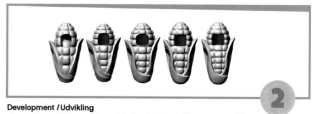

The final Product datasheet /
Det færdige resultat og dataark

3

A CORN COB GUY GROWS IN BILLUND

STEP 1. EARLY SKETCHES

Minifigures start with a conceptual sketch. In 2017, senior graphic designer Austin Carlson pulls Corn Cob Guy from the master list of minifigure ideas, and passes it on to Paul Wood, a senior designer who works primarily on elements—including the "sandwich board" suit that Corn Cob Guy will need to don.

STEP 2. 3-D MODELS

Working with sculpting software, Wood renders Carlson's vision in three dimensions. This is harder than it sounds. "At first it was three kernels between his face and the bottom, and Tara [Wike, senior design manager] said, 'Could you just add one more row?' And then another row. It was just constantly shoving in more kernels," says Wood.

STEP 3. FINE-TUNING

Over a period of four weeks, Paul Wood continues to refine Corn Cob Guy's cover-up, sending digital models to the 3-D printer every evening for prototypes that await him the next the morning. "As we get into it later and later, the engineers ask about the arms, and the design lab asks about the back and does it fit in a LEGO grid," says Wood. Austin Carlson adds a mustache to provide contrast to the yellow kernels and head; the face portal widens to accommodate it.

STEP 4. CORN COB GUY LIVES

To produce the sandwich board piece, LEGO production uses a recent technological breakthrough called two-component molding, which allows two colors of plastic—in this case green and yellow—to coexist in a single element The result: more color fidelity and consistency versus printed graphics. And one fine-looking minifigure husk.

"IT TOOK SOME TIME FOR THE COMPANY TO EMBRACE THAT THE MINIFIGURE WAS A BIG PART OF THE PLAY EXPERIENCE, INSTEAD OF SOMETHING THAT YOU ADD TO THE BOX ALONGSIDE A REALLY COOL MODEL." —TARA WIKE, SENIOR DESIGN MANAGER

RARE MINIFIGURES

Minifigures are inherently egalitarian. It's a natural by-product of being basically identical for several decades. But some minifigures still rise to the level of collector's item, commanding hundreds or even thousands of dollars on the secondary market.

What drives up the value? Like anything else, supply and demand. The LEGO Group has periodically tied limited-edition runs of minifigures to special events. Exhibitors at the 2009 LEGO Fan Weekend in Denmark, for instance, received a relatively plain-looking minifigure—brown hair, blue legs, typical smile—that is now one of the rarest around, thanks to its distinctive printed torso.

Were you at San Diego Comic-Con in 2012? You could have grabbed a Shazam, Bizarro, Venom, or Phoenix, but you had to move fast; there were only 1,000 of each available. Or if you made it to the New York Toy Fair that same year, you could have picked up ultra-rare Captain America and Iron Man minifigures.

Given how popular LEGO *Star Wars* has become, it shouldn't come as a surprise that minifigures from a galaxy far, far away fetch a high price on the open market. A few of those came in since-discontinued sets; Cloud City Boba Fett came out in 2003, and was the only brick bounty hunter with printed designs on his arms and legs at the time. Others are promotional tie-ins, like the 1,000 Yodas in I (Heart) NY shirts that Toys 'R' Us bundled with X-wing playsets in 2013.

But the rarest of the rare LEGO *Star Wars* minifigures are prized for their materials as much as their scarcity. C-3PO in particular has gotten a few metallurgical boosts: In 2007, the LEGO Group made only five 14-karat-gold representations of the droid as part of a sweepstakes to celebrate thirty years of the *Star Wars franchise*. R2-D2 has been kitted out in platinum and sterling silver. And there are two—yes, only two—Boba Fett minifigures made entirely of bronze.

While not the most expensive minifigure today, the most widely recognized rarity might be Mr. Gold. Rather than promoting a movie or convention, Mr. Gold was intended as a celebration of Series 10 in the Collectible LEGO Minifigure Series. The company produced 5,000 of the chrome gold-plated Minifigure in 2013, and created a map online where people who found him could log their location. Think of Mr. Gold as the Willy Wonka golden ticket of the LEGO world.

Mr. Gold was a hit, but don't expect a Mr. Platinum follow-up anytime soon. "You could say that was successful, but some factions in the company frowned upon it," says Wike. "We don't want to promote elitism." With included stands and accessories, Mr. Gold commands a couple thousand dollars on reseller sites today. Just remember that all that glitters is not chrome; the internet is flooded with fakes.

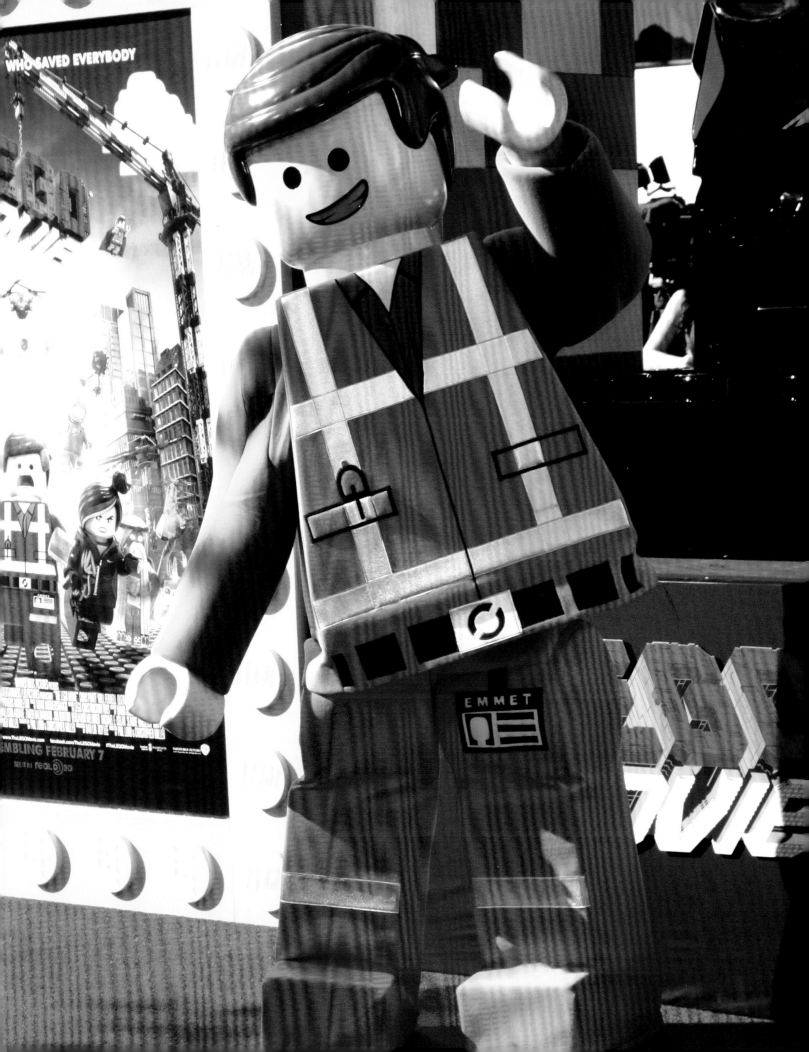

CHAPTER 7

LIGHTS, CAMERA, EMMET

n the decade after the launch of the LEGO® *Star Wars*™ line, minifigures spent much of their time starring in other people's adventures, from *Harry Potter* to *Spider-Man*. The Collectible Series helped minifigures explore new careers—and species—but they lacked an overarching narrative to call their own.

It's not that the LEGO Group hadn't explored storytelling. Every set tells its own tale in miniature, after all. And some lines, like LEGO® Atlantis, had a considerable backstory built in. The company even dabbled in years-long arcs through its BIONICLE ® series, which lasted through most of the aughts.

Enter LEGO® NINJAGO® in 2011. Inspired in part by ninja-themed sets that had launched as part of the LEGO® Castle line in 1998, the NINJAGO TV series and corresponding sets follow the adventures of four minifigure ninja with elemental powers. More important than the specific subject matter is how NINJAGO helped evolve the minifigure's role, both literally and figuratively.

"The characters have their own identities. That can also inspire the play," says Cerim Manovi, senior design manager for the NINJAGO team. "If you have a city policeman, it's a city policeman. If it's a ninja, that gives you a little bit of identity but not much. Children know ninja have cool weapons, they can hide, they can do martial arts. But then having something you can identify and relate to, that's where it really gets strong."

NINJAGO gave fans fully formed characters. As they evolved from season to season on TV, their minifigures did as well, whether through something as simple as a costume refresh or something more nuanced like facial expressions that reflect their emotional journey. Or in a more extreme case, in 2015 the "ice ninja", Zane, adopted a titanium body.

Through NINJAGO, the company also fine-tuned the interplay between the sets and the show. Cerim Manovi and the team at the LEGO Group work closely with the writers to pinpoint moments in an upcoming season that can also play out on the boxes of sets. There's always a chase scene; there's always a big showdown. Every centerpiece moment of each season shows up in a LEGO set that children can build themselves, with minifigures leading the (sometimes literal) charge.

OPPOSITE: Character explorations for the NINJAGO play theme.

LEGO NINJAGO

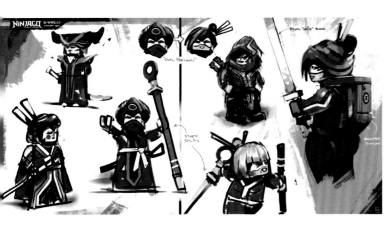

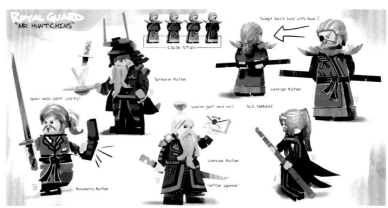

CELESTIALS CONCEPTS

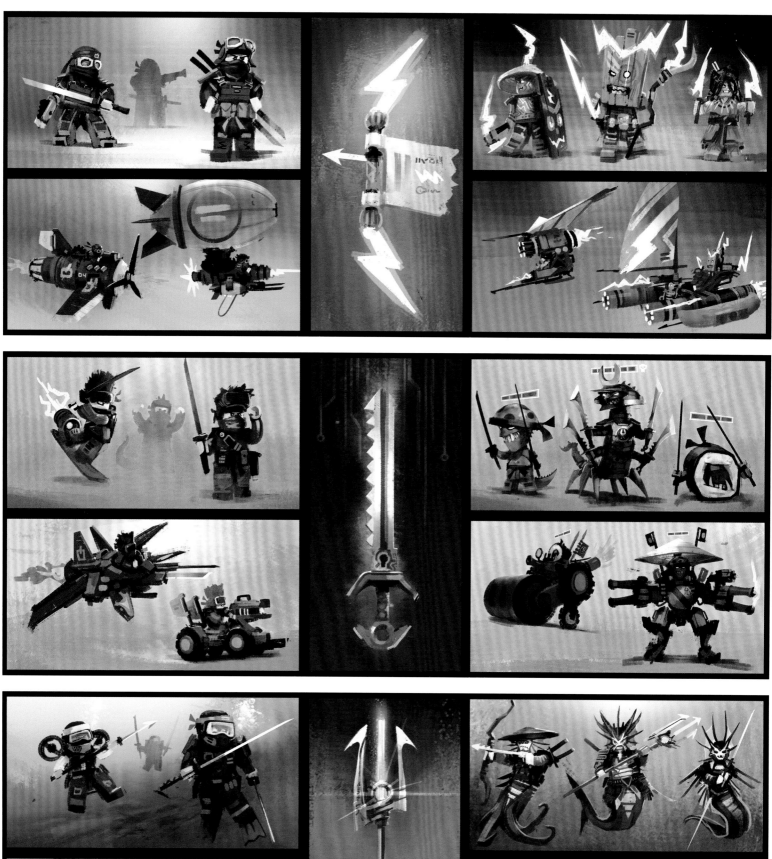

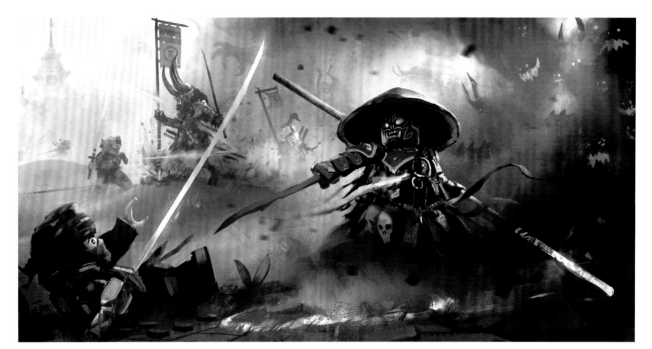

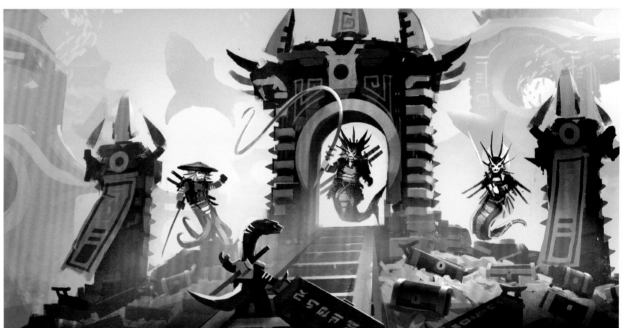

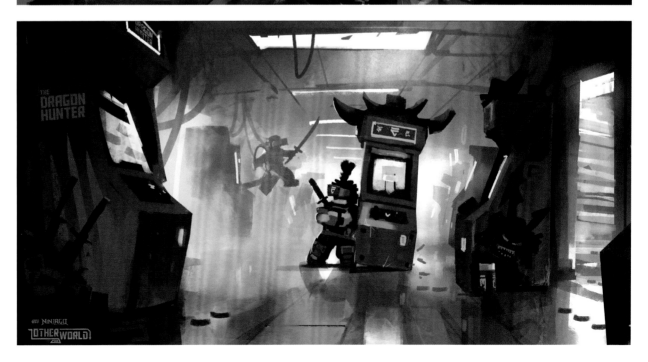

THE DRAGON HUNTER

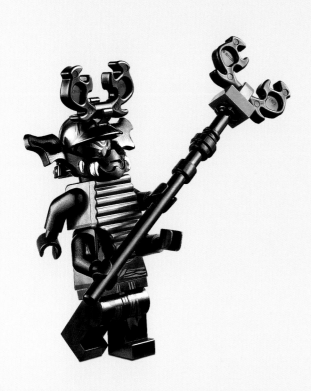

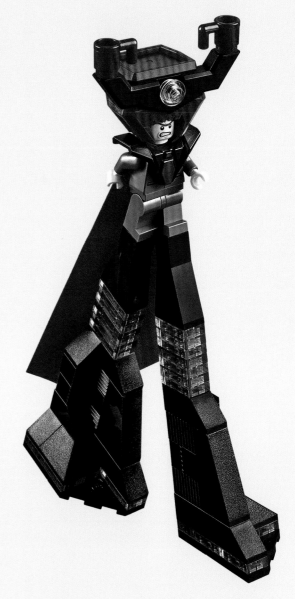

DOUBLE UP

Many minifigure firsts were inspired by the needs of licensing partners. But you can thank NINJAGO bad guy Lord Garmadon for introducing the first double torso. Previous characters had sported four arms—looking at you, General Grievous—but had squeezed them into the existing paradigm. Garmadon got tall.

ALL BUSINESS

It's safe to say that Lord Business had a tough time navigating the minifigure gauntlet. While LEGO designers try to recirculate pieces and elements among different sets as much as possible, creating a villain this over-the-top required a few one-offs. As always, the focus came back to the System. "He had his big boy boots to make him taller and more imposing than everybody else," says vice president of design Matthew Ashton. "We needed to develop special legs for him, so you could build something that wouldn't fall to pieces as the children were playing."

A NINJAGO JOURNEY

Zane's been through some things, which ultimately is a testament to the longevity—and bottomless well of creativity—the NINJAGO team has exhibited for nearly a decade.

While 2017's THE LEGO® NINJAGO® MOVIE™ is mostly animated, its live-action opening scene includes one of the rarest minifigures of all: a wooden rendering of Master Wu. Four were made for filming, and none were sold to the public. And while it's missing some classic minifigure characteristics, what it lacks in articulation it makes up for in artistry.

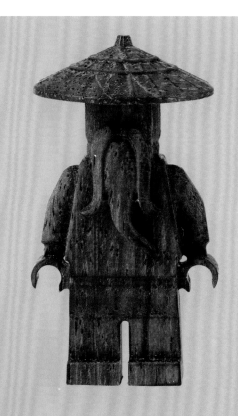

The success of LEGO NINJAGO proved that minifigures could take the lead in homegrown stories that resonated with a huge audience. But it wasn't until a few years after it first aired that minifigures would go supernova. For that, they would need a feature-length film, one that for the first time stayed unwaveringly true to their roots.

The LEGO Group had made a handful of films before 2014's THE LEGO® MOVIE™, albeit ones that aired on television rather than in theaters. *The Adventures of Clutch Powers*, released in 2010, even put minifigures front and center. But those early efforts weren't yet able to replicate how a minifigure actually moved.

"Most LEGO animation, up until this point, had a rubbery, squishy quality which worked perfectly for video games," says Matthew Ashton. "For THE LEGO MOVIE I thought it would be nice if we could also have the minifigure behave in a way that was much truer to the performance and articulation of the actual toy."

Fortunately, THE LEGO MOVIE directors Phil Lord and Christopher Miller took their inspiration from the fan community's stop-motion efforts. If you're going to make a movie about minifigures, they should move like minifigures. Rather than gloss over those limitations, why not build the entire film around them?

"We can't pretend that the minifigure is modern," says Tara Wike. "It's a forty-year-old blocky figure, so embracing that and running with it was a really smart move."

Well, maybe not quite running, at least at first. There was considerable skepticism, Ashton says, that they'd be able to get a full range of emotions out of lead "actors" with such a limited range of movement. Directors Miller and Lord agreed to do some test animation to prove out the idea. Fortunately, it worked.

"To take that leap and go the other way to make the quality based on the limitations of the minifigure was quite a bold step, but to me it was the most obvious thing that we should be doing," says Ashton. "The limitations themselves add to the humor and the performance of the characters. They can't do everything that a real person can do, but it's kind of funny that they can't."

Take everything the film's hero Emmet does. Or take his calisthenics, at least: A minifigure's legs don't spread sideways, so he does his jumping jacks front to back. It's funny! More importantly, it's a distinctly LEGO design feature. Rather than literally bending the minifigure to fit the needs of other universes, THE LEGO MOVIE shaped the world around its leads.

In doing so, it also defined so much about minifigures that had been assumed but not codified, shading in not just how they move but also how they act. "The animation team did such a good job encapsulating the kind of personality that I think we believe the minifigures have," says Tara Wike. "This sort of sweet innocence and crafty cunning . . . and wholesomeness."

The Big Yellow Book helped there. But so did small touches that you may not have noticed on your first or even third viewing. Emmet's not based on any specific historical LEGO minifigure, but he's clearly a throwback. He has the classic-inspired hairpiece, sure, and a generic outfit. But while most other minifigures in the movie have eyes with white dots and highlights—details that had been introduced over a decade prior—Emmet sticks with two simple black dots.

The commitment to minifigure fidelity was physical as well, down to the visible lines where molded pieces fit together. To ensure those details showed up accurately—especially blown up on a 30-foot movie screen—LEGO designers developed every element at the same time the digital files were created for the film. Practically

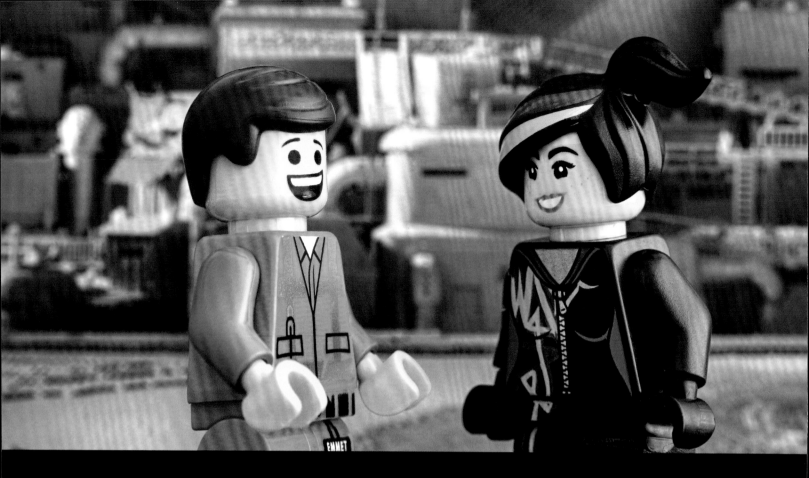

WYLDSTYLE'S WILD STYLES

"For Wyldstyle in particular, the directors and the team wanted her to be really badass and quite aggressive, quite like Trinity from *The Matrix*, borderline *Tank Girl*. Yes, we needed to get that through in her but at the same time we need to rein her back a bit. It was that fine line of keeping some of those attributes but creating something that was still very aspirational and attainable."

—Matthew Ashton, Vice President of Design

everything that shows up in THE LEGO MOVIE also fits in System in Play.

"Typically speaking, we don't like [creating something] digitally that we're not going to make a product out of," says senior designer Paul Wood. "People see it in the movie and want it."

That doesn't mean there weren't occasional cheats, sprinkles of movie magic and motion blur to keep things moving. For the half-second that Emmet is shown brushing his teeth early in the film, his arm is popped out and comes in from the side. But that there are so few exceptions shows just how true to minifigure movement THE LEGO MOVIE is—no small feat, especially given its emotional punch.

"It's just making sure that despite having the same rigid articulation there are still things you can do with the performance," says Ashton. "The speed the character walks makes it positive or depressed. That's so simplistic but so emotive at the same time. Just putting a few extra highlights in a character's eyes when they get upset, or a wobble in their lips. A lot of it's just in those minute little details and twitches in their faces."

THE LEGO MOVIE brought years of hard work to the big screen, representing a close collaboration between the LEGO Group, Warner Bros., and Animal Logic, whose team of over 350 artists, technicians, and support staff spent more than two years on the film. The film was also the perfect reflection of the internal work that the LEGO Group had put into imbuing the minifigure with traits that extend well beyond the four corners of the original patent. There are more of them than ever, but their DNA has never been so consistent.

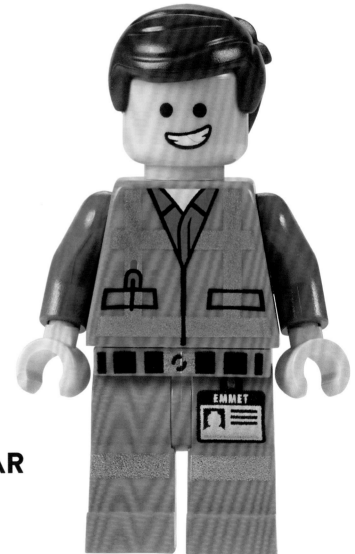

FIRST MOVIE STAR

(Emmet '14)

CHAPTER 8

WHAT COMES NEXT?

The long-term future of the minifigure is a closely guarded secret. But you can already see glimpses of where the LEGO Group might intend to take it.

In 2017, the company launched LEGO® Life, a safe space for children to show off their builds online. Like any good social network, LEGO Life has a newsfeed and profiles and user-generated content. But while LEGO Life is focused on all sorts of builds, it deploys minifigures in a way that's sublimely thoughtful. Fascinating, even.

First, real-life profile pictures aren't allowed on LEGO Life. These are mostly children, after all. Instead, you can trick out a minifigure avatar exactly how you like it, with dozens of faces, torsos, hairpieces, legs, and accompanying elements to choose from. It's a privacy measure, but also the *ne plus ultra* of minifigure as self.

It's also a clever way to cross the physical-digital divide, an increasingly important focus for not just the LEGO Group but every toy company. (Every company, period, for that matter.) Piecing together your own minifigure out of buckets of spare parts is one of the best parts of visiting a LEGO retail store. You can capture that same spirit anytime you open the LEGO Life app.

Then there are the comments. You can leave them with a traditional keyboard, but the preferred method on LEGO Life—and the only option when it launched—was emojis. And not just any emojis, but minifigure heads and elements offering a range of expressions and icons. A Captain Redbeard is worth a thousand words.

Beyond helping keep things kind in the comments, leaning on minifigures also helps make LEGO Life truly universal. It debuted in eight countries simultaneously; with minifigures, nothing gets lost in translation.

Most of all, LEGO Life shows the minifigure's adaptability to new terrain without sacrificing its core decency—no easy feat on social media, especially. It's the same trick that made THE LEGO® MOVIE™ so successful, and provides a blueprint for whatever future innovations are in store. The medium will adapt to fit the minifigure, not the other way around.

My new look!

My Cool Creation!

My Cool Creation!

Feeling all bricky today

In LEGO Life, you can make a digital minifigure that looks just like you—or go the exact opposite direction.

You can see that in other areas where the real and digital worlds converge. In 2019, the LEGO Group introduced a new theme, called LEGO® Hidden Side, which layers augmented reality on top of a traditional brick experience. They have a story line as well: Ghosts have flooded the sleepy town of Newbury; it's up to you to find them. Both ghosts and paranormal investigators, naturally, are minifigures.

Hidden Side uses augmented reality and a smartphone app to make those spooks come to life, as it were. But in a very LEGO way, it emphasizes the building process, encouraging children to create something in the real world first rather than heading straight for a screen.

"Children expect exciting play experiences that move seamlessly between physical and digital worlds—something we call "fluid play," said Tom Donaldson, senior vice president of LEGO Creative Play Lab, when Hidden Side debuted. "We're breaking the mold of gaming-first AR play experiences to create a new type of play where the physical world actually influences the AR layer, instead of the other way around."

Even beyond the technological hook, Hidden Side shows how integral minifigures have become to the company's future. Hidden Side came with a rich narrative built in; the gameplay pushes that story forward as you go. The company even mounted a series of animated shorts to support the line. It would be impossible to build out new worlds so fully without minifigures taking the lead.

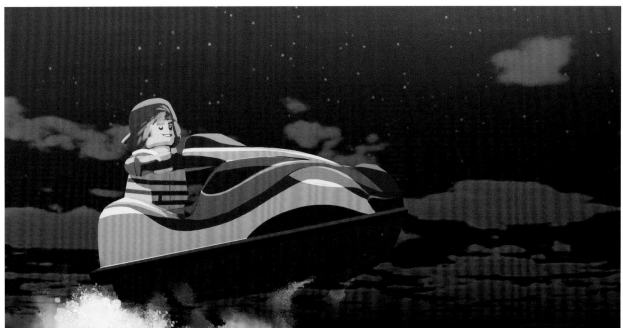

 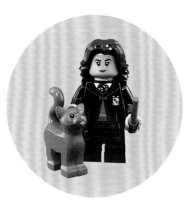

ABOVE: A little leg height makes a big difference. By introducing the medium-size minifigure leg, LEGO designers created another height option for characters that lets them articulate and sit — which the shortest legs still can't do. (Sorry, Dobby.)

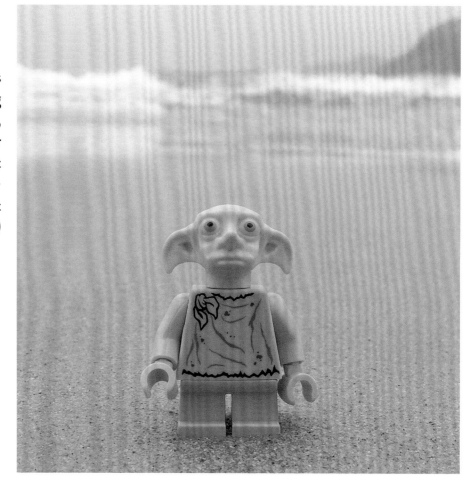

The minifigure itself is changing too, albeit slowly. While designers still largely adhere to the constraints of the patent, the last few years have seen important adaptations.

LEGO designers first made short legs for minifigures in 2002, to accommodate *Harry Potter* house elf Dobby. They'd go on to grace *Star Wars* Ewoks, *Lord of the Rings* dwarfs, and other diminutive mystical creatures. But while perfect for world-building, there's a catch: They can't move. No running, no sitting, just stoic poses. And while the short legs enabled proportionally accurate goblins and children, designers still had no way to create a convincing teen.

It wasn't until 2018 that the company forged a compromise. As part of its Wizarding World Collectible LEGO® Minifigure Series, the company introduced its first medium-size legs, which as you might have guessed fit snuggly between the short and standard versions. Not only did they allow for LEGO teens—important for a convincing *Harry Potter* world—but also the new legs could actually move. This added a way to represent an even greater range of character appearance. And since medium legs allowed room for holes in the back, they could more actively engage with sets around them.

Adding a few millimeters to a leg piece may sound obscenely incremental. For the LEGO Group, it was anything but.

"This was uproarious in the design world," says senior design manager Tara Wike. "Do we really want to invest in new equipment to make these other kinds of legs? But it allowed us to actually have children who could sit, which is a big deal in a lot of the sets."

That it took decades to get there, though, speaks to how adaptable the original minifigure design is. Changes have come slowly in part because there's so little to change. Designers love and respect the minifigure, and agree that innovation must always be deliberate. Done without extreme care, change would more often than not undermine the System in Play.

"New designers have all this schooling behind them, and all these design ideas. They have this tendency to forget that kids are kids," says LEGO designer Niels Milan Pedersen. "The minifigure is actually working really well. If you take the figure and make it more movable, maybe we've tried that, but what you find out is it's going to be impossible for a child to handle."

That doesn't mean there's no room for improvement. The medium legs addressed blind spots in proportion and functionality; other adaptations have focused on representation. The company added a baby figure to its collectible Series in 2016, and its first minifigure in a wheelchair that same year as part of the City theme.

Both Tara Wike and Matthew Ashton have also stressed the importance of making minifigures less overwhelmingly male. The Collectible Minifigure Series has led that charge, but LEGO® City and other themes have more actively pursued gender equality in recent years as well.

It also seems possible that LEGO designers might someday draw inspiration from its fan communities, who are already dabbling in custom minifigure modifications through 3-D printing and other technological advances. "If you really go into the future, I think there's definitely something for 3-D printing or prototyping where you can really customize the character and make your own unique contribution," says NINJAGO senior design manager Cerim Manovi. "If that gets more mainstream as a service, like I can choose this version or that version of the character in the box, that is a huge possibility of how we can innovate."

ABOVE: Expect the company to continue pushing for more inclusivity, as with its first minifigure in a wheelchair, which debuted in 2016.

LEFT: Aww! Fans embraced the youngest member of the minifigure family that same year.

OPPOSITE: Popular sets like Research Institute (set #21110) and Women of NASA (set #21312) highlighted women in science, and showed the fan demand for interesting and equitable roles for women and girls.

EVERYONE IS AWESOME.

EVERYONE IS WELCOME.

To celebrate the diversity of the world and the creativity of the LGBTQIA+ community and their allies, in 2021 the LEGO Group launched a set called LEGO® Everyone Is Awesome. The set is inspired by the Pride Flag, a symbol of love and acceptance amongst the LGBTQIA+ community, and features 11 monochrome minifigures, each with its own individual hairstyle and rainbow color. It reflects the LEGO Group's belief that everyone is awesome and that with a little more love, acceptance, and understanding in the world we can all feel free to be our true, awesome selves.

"If I had been given this set it, would have been such a relief to know that somebody had my back. To know that I had somebody there to say 'I love you, I believe in you. I'll always be here for you.'" —Matthew Ashton, Vice President of Design, and designer of set #40516 Everyone Is Awesome

WHAT COMES NEXT?

WOMEN OF NASA

Maia Weinstock grew up playing with LEGO sets in the 1980s, but it wasn't until 2009 that she rediscovered building as an adult. In the process of doing research for an animated short film, she came across a custom, fan-designed minifigure of pioneering mathematician Ada Lovelace. It sparked something.

"I decided it would be fun to try my hand at making these little LEGO minifigures that look like real people," says Weinstock, deputy editor at *MIT News*. "It was really sort of a fun whim, not any kind of big project."

Instead of historical minifigures like Lovelance, Weinstock opted to focus on living luminaries in the fields of science and engineering. She started with Carolyn Porco, a planetary scientist who had been deeply involved in NASA's *Cassini* spacecraft mission to Saturn. "She enjoyed it, and I enjoyed making them, so I decided to try other people as well," says Weinstock.

In her spare time, Weinstock pieced together her homemade minifigure homages, gaining some notoriety as she shared them on Twitter. Partly in response to the debut of the girl-focused Friends line in 2012—which uses taller figurines rather than minifigures—Weinstock concentrated her efforts on minifigure representations of women. In addition to Porco, she re-created scaled-down versions of astronaut Ellen Ochoa, physicist Lisa Randall, and marine biologist Sylvia Earle, among others. In 2014, Weinstock displayed her minifigures as part of an exhibit in Austin, Texas, devoted to portraits of women in STEM.

The following year, still at work on even more ambitious projects, Weinstock heard of a site called LEGO® Cuusoo—now known as LEGO® Ideas. The premise of the site is both simple and unique: Amateur LEGO builders show off their designs, and the community votes on whether they want it to become a real set. Get 10,000

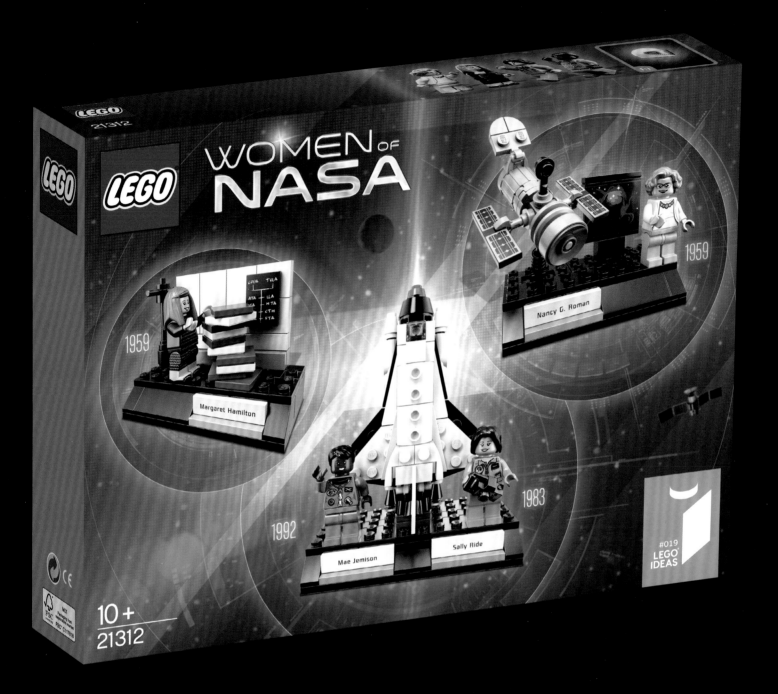

supporters, and the LEGO Group will review your entry and, quite possibly, approve it for production.

For her first LEGO Ideas submission, in 2015, Weinstock's artistic side led her to create Legal Justice Team, a collection of minifigures featuring Supreme Court justices Sandra Day O'Connor, Ruth Bader Ginsburg, Sonia Sotomayor, and Elena Kagan. While it received a wellspring of support, the project was ultimately declined, as LEGO

egulations prohibited featuring currently serving members of the government. Her next effort, the Bioneers, focused on women working in biochemical fields. It failed to reach the requisite level of support

The third time was the charm.

"I decided to go back to my core interest throughout my life which has been astronomy and space sciences," says Weinstock She got to work on a set that would celebrate four women who have made deeply meaningful contributions to space exploration: computer scientist Margaret Hamilton, astronomer Nancy G. Roman mathematician Katherine Johnson, and astronauts Sally Ride and Mae Jemison. She would call it Women of NASA.

Re-creating real people realistically as minifigures isn't quite as simple as sorting through the tower of spare parts at the LEGO Store Like many minifigure enthusiasts, Weinstock outsources components. For Women of NASA, she used Bricklink, a sort of eBay for extra LEGO elements—organized by set number, body part, type of element, you name it—to gather the foundational pieces. To nai details like glasses and custom prints, Weinstock turned to online stores offering elements not officially produced by the LEGO Group at the time.

Finally, Weinstock felt she had it down. She submitted her series of minifigure vignettes in 2016. It took just over two weeks to hit 0,000 votes. The following year, the LEGO Group produced the set—minus Johnson, whose family declined to participate. For senior design manager Tara Wike, the experience was both exciting and stressful.

"At this point I had probably designed 300 minifigures, but had never designed one for a person, their personal self," says Wike, who worked directly with Hamilton, Jemison, Roman, and Tam O'Shaughnessy, Sally Ride's longtime partner.

Roman said she was happy to let LEGO designers take the lead One down, three to go.

Weinstock had based her Hamilton vignette on an iconic photo of the software engineer standing next to the towering stack of papers

that comprised the code used in the Apollo space program. Yet, when Wike asked her for reference images, Hamilton kept pointing toward an image of her in the Apollo command module. Hamilton's final minifigure representation does stand next to reams of code—but her dress, face, and hair all reflect her favorite photograph.

Mae Jemison presented a slightly different challenge. Wike's team had attempted to give her minifigure a contemplative facial expression, but Jemison was concerned that it looked too grumpy.

"We had a hilarious phone meeting about it. I just remember both of us laughing the whole time," Wike recalls. To keep the face design from looking too grumpy, Wike suggested a raised eyebrow. Intent on accuracy, she asked Jemison if she could raise an eyebrow, and if so, which one? The astronaut took a moment to double-check.

"She looks in the mirror and says, 'No, I cannot raise an eyebrow. But I would love to, and I've always admired Spock on *Star Trek*, so whichever eyebrow he can raise, please do that one,'" Wike recalls.

By November 2017, Women of NASA was ready to launch. The day it was released, Weinstock recalls, it was the top-selling toy on Amazon.

Women of NASA is worth a longer look because it's a fabulous set of minifigures. But it also underscores the unique relationship that the LEGO Group has with its community of fans. Many best-selling sets have sprung up from LEGO Ideas projects, constituting an unparalleled two-way street. "It's really rare to actually have a company reaching out so directly to its fans and asking for real product ideas," says Weinstock. "There have always been Adult Fans of LEGO (AFOLs), but now they have an avenue to express their artistic side and some of their technological, building side in ways they weren't able to before."

MEET THE ORIGINAL. A BLANK CANVAS TO TELL YOUR STORY AND EXPRESS YOUR WILDEST MINIFIGURE DREAMS.

Inspired by the first wooden toys handcrafted by LEGO founder Ole Kirk Kristiansen, The Original was released in 2019 and is a 5:1 upscaled version of the classic minifigure. While most of it is solid oak, the hands remain plastic—and grippy. LEGO employees were given the opportunity to create their own take on the minifigure. Shown here (from top left, clockwise) artwork by Margit Rosenaa Platz, Jake Blais, Roberta Sandri, Li-Yu Lin, Katharine Graham, and Crystal Marie Fontan.

And then there's sustainability, which matters to the LEGO Group. Building a sustainable future and making a positive impact on the planet is a key focus, touching all parts of the business and products. In 2015, the LEGO Group announced its ambition to make all of its core products from more sustainable materials by 2030, investing $150 million in furthering the company's research and development in this area. In 2018, it took an important step toward that goal, debuting a few dozen elements made out of sugarcane-based polyethylene rather than oil-based plastic—the material is now used in over 100 elements including minifigure accessories, and in general, you can find them in more than 40% of LEGO boxes today. The LEGO Group committed a further $400 million to accelerating its sustainability ambitions across a number of areas including sustainable material development in 2020.

In the summer of 2021, the LEGO Group revealed its first prototype LEGO brick (a classic 2x4) made of recycled polyethylene terephthalate (PET). PET is the plastic used in most disposable bottles. A team of more than 150 people are working to find sustainable solutions for LEGO products. Over the past three years, materials scientists and engineers tested over 250 variations of PET materials. With the sustainable materials ambition always front of mind, the LEGO Group is making progress—and is committed to including the minifigure in every step of that journey.

No matter what it's made of—or how it evolves—the minifigure has solidified its place as an icon, both within the LEGO universe and beyond. It reflects culture back at us; in some ways, more than ever, it helps create it. That's not changing anytime soon.

"As far as I'm concerned," says Matthew Ashton, "as long as I'm at the company, the minifigure's going nowhere."

RIGHT: The bushes, trees, and even some dragon wings in LEGO sets today are already made of plant-based plastic. Sustainable materials experts at the LEGO Group are hard at work developing new renewable and recycled materials for LEGO products.

NEXT SPREAD:
One Form, Reborn
by Thomas Dambo, artist,
and Artboost, curator

Unused LEGO® Packaging & Instructions

Old Work Clothes

Reused Cardboard Boxes

Recycled Copper Wire

Discarded Pallets

Defect LEGO® Bricks

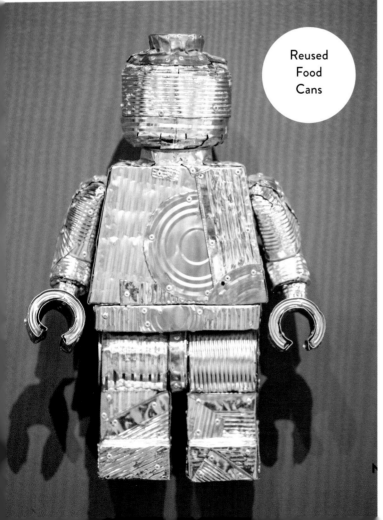

Reused Food Cans

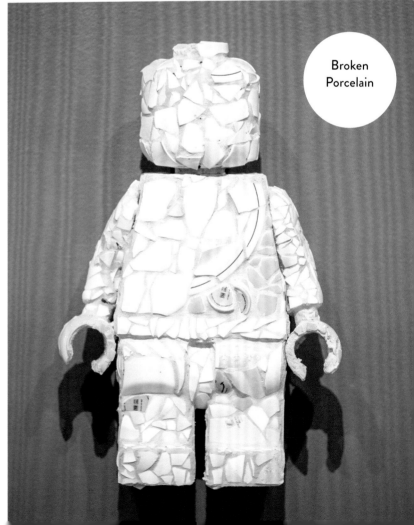

Broken Porcelain

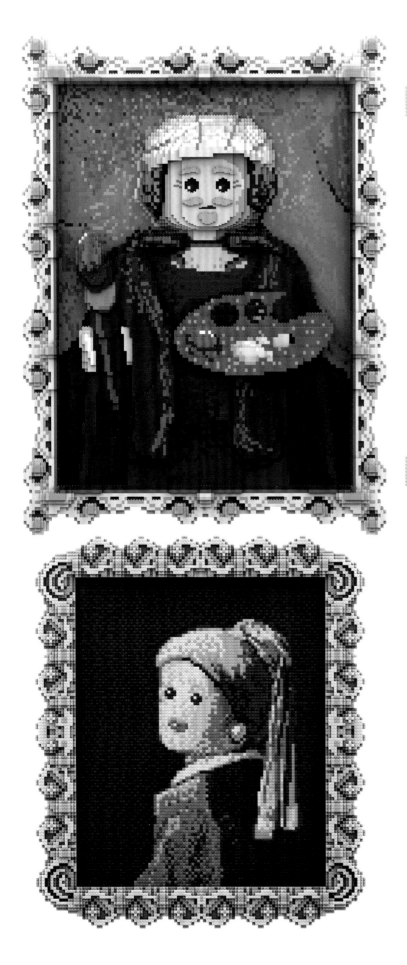
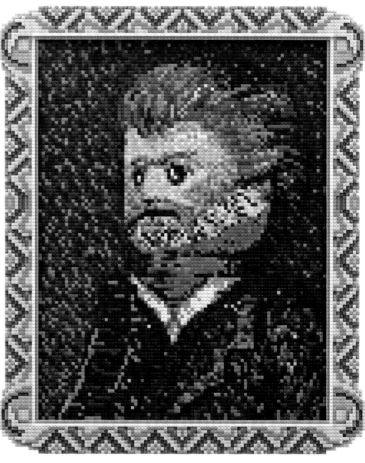
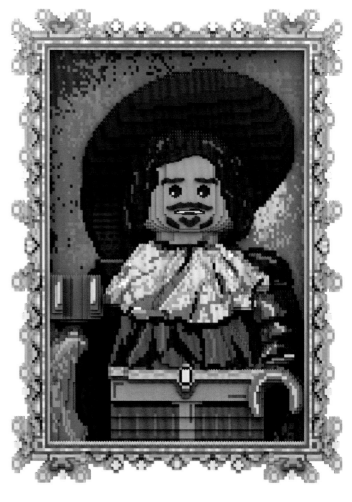

FINAL THOUGHTS

Well into its fifth decades, the minifigure has evolved in ways both subtle and profound. It's a model of both consistency and adaptability, a blank screen onto which you can project everything from beloved pop culture characters to a guy in a hot dog suit. Most of all, though, it's a conduit. Rather than simply observe that elaborate set you built—or that augmented reality world—the minifigure turns you into a participant.

However many forms the minifigure takes, whatever materials it's made of, whatever technologies it adapts to, that role seems unlikely to change. They're what elevates a collection of bricks from a set to a story. They suggest how worlds might work without dictating the action. The LEGO® System in Play requires everything to fit just right—and nothing ties it all together like a minifigure.

PHOTOGRAPHY CREDITS

All photographs and illustrations © The LEGO Group, except for the following:

pp. 3, 56–57, and 90: Blake Powell

p. 17 (far right bottom): Brittany McInerney

p. 29 (top): Shutterstock/Lena Ivanova

p. 32–33 by Naomi McColloch

p. 41: iStock by Getty Images/mattjeacock

p. 48: Shutterstock/M88

p. 60: Shutterstock/Lewis Tse Pui Lung

p. 71 (skeleton): Shutterstock/Lewis Tse Pui Lung

p. 76: Shutterstock/Levent Konuk

p. 79: iStock by Getty Images/BrendanHunter

p. 84 (bottom): Shutterstock/cjmacer

p. 87: Shutterstock/motoDanmoto

p. 88: Shutterstock/StockPhotosLV

p. 104: Shutterstock/miszaszym

p. 105 (top): Shutterstock/aigphoto.com

p. 105 (bottom): Shutterstock/miszaszym

p. 108: Shutterstock/Kathy Hutchins

p. 117: Shutterstock/Kathy Hutchins

p. 118: Shutterstock/Ekaterina_Minaeva

p. 120: Shutterstock/Lewis Tse Pui Lung

p. 126 (bottom): Shutterstock/mini_citizens

p. 129: Shutterstock/Ekaterina_Minaeva

p. 138: Shutterstock/8H

ABOUT THE AUTHOR

BRIAN BARRETT is an executive editor at WIRED, where he oversees daily coverage across of a variety of topics. He was the editor in chief of the tech and culture site Gizmodo and a business reporter for the *Yomiuri Shimbun*, Japan's largest daily newspaper. His work has appeared in the *New Yorker* and *New York Magazine* online, as well as in *Real Simple, Details, Country Living,* and more.

ACKNOWLEDGMENTS

Thank you to the team of people who provided interviews, contributions, artwork, and support to this publication, including: Randi Sørensen, Martin Leighton Lindhardt, Heidi Jensen, Jette Orduna, Tara Wike, Matthew Ashton, Kristian Reimer Hauge, Paul Hansford, Hanne Mørk Hede, Tess Howarth, Therese Noorlander, Sarah Wind Christiansen, Brian Poulsen, Jan Ryaa, Niels Milan Pedersen, Jens Kronvold Frederiksen, Karsten Juel Bunch, Alexandre Boudon, Austin Carlson, Paul Wood, Cerim Manovi, Tom Donaldson, Maia Weinstock, Thomas Dambo, Artboost, Brittany McInerney, Sara Schneider, Alison Petersen, Maddy Wong, Michelle Clair, Christina Amini, Brooke Johnson, and Aki Neumann.

BRIAN BARRETT is an executive editor at WIRED, where
he oversees daily coverage across of a variety of topics. He
was the editor in chief of the tech and culture site Gizmodo
and a business reporter for the *Yomiuri Shimbun,* Japan's largest
daily newspaper. His work has appeared in the *New Yorker* and
New York Magazine online, as well as in *Real Simple, Details,
Country Living,* and more.

Manufactured in China.

Cover design by Sara Schneider.
Cover Photograph by Naomi McColloch.